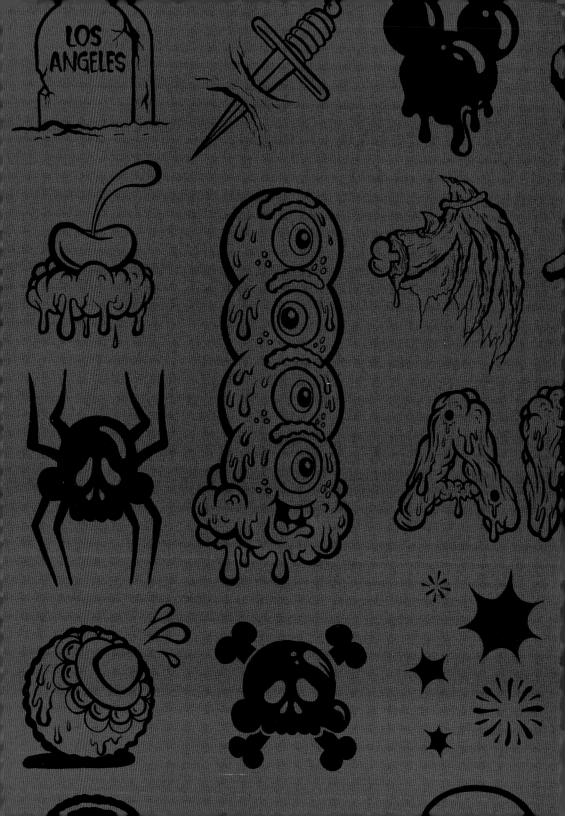

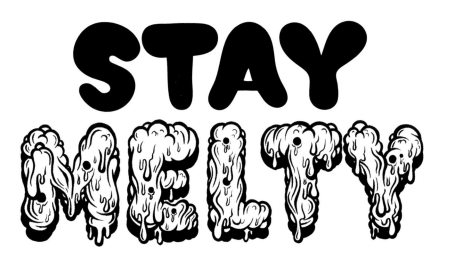

STAY MELTY

BUFF MONSTER

TO GUY + KATY

BUFF
MONSTER
16

GINGKO PRESS

This book is a collection of just some of what I've created over the last three years. I hope you like it. The characters are quite lighthearted, but I take my job very seriously. I just like to work, and there's no substitute for working hard. I truly appreciate the help of my family, friends, fans, collectors, clients and vendors. Thanks for your support! *Stay Melty!*

Pretty (Weird) in Pink
Buff Monster & the Art of Otherness

By Carlo McCormick

There is a kind of confabulation in our culture, like a selective amnesia where reality is forsaken in favor of fantasy. Because so much of this confusion between verity and its verisimilitude is engendered by the most cloyingly mundane of media, and in part due to the ugly fact that sometimes these displacements rise up in aberrantly psychotic episodes, it's easy to wring one's hands with dread over how the fictions of the dream machine have come to subsume our experience and understanding of the world around us. There is however a realm of magical thinking in contemporary visual culture where a very few rare artists like Buff Monster can invoke alternate realities as palpably believable and emotionally transformative that we can only be thankful for our most human proclivity to misconstrue image and imagination.

Buff Monster is a matter of pure invention, both as an individual who has adopted a persona and as a disseminator of made-up characters so delightfully likable that they supplant and subvert the quotidian world into which they are injected. No doubt when he travels, which he does nearly nonstop with his itinerant approach to changing this planet with his art, there is a passport that bears the name he was given at birth, but in the alias-rich sphere of street art and graffiti from which his work arises most artists get around to sharing at least their first name with one another he remains adamantly affixed to his surrogate identity. Even his girlfriend calls him Buff. This vesting of veracity into the charade of illusion that he exercises in his own life is what similarly animates his art. Perhaps seeing him about with his hair spiked up in a Mohawk and making pictures so weird in the scheme of academic formalisms abounding today, he might seem a bit like a cartoon character himself, but that's also just as much to say that looking at his comical characters is to see Buff Monster, the man, more deeply.

For whatever fabrication has gone into the construction of Buff Monster's identity, he remains one of the most startlingly sincere and truthful artists out there, and it is that probity of pure honesty that allows so many of his avid fans to relate to his most fanciful of pictorial personages as authentic on their own terms. And this, of course, is what makes them work. Buff's creatures, fantastical though they are, are relatable and personable precisely because they're as

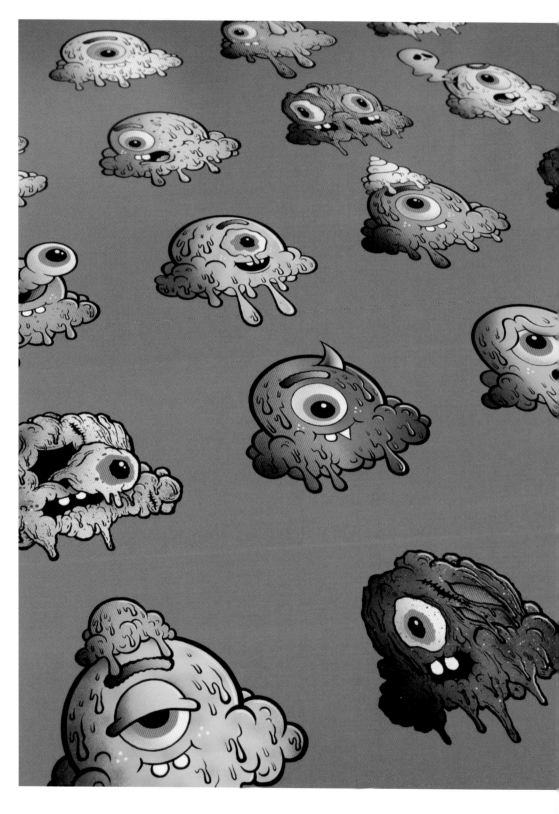

"This vesting of veracity into the charade of illusion that he exercises in his own life is what similarly animates his art."

flawed and farcical as the rest of us. They infect our heart like beautiful losers not as ideals so much as paradigms, seeming real in craft and consciousness alike, not by some Disneyesque magic of Imagineering, but as grotesque metaphors for the kinds of character blemishes we all carry with us. Caricature, rendered with such representational precision and faux-realism, can indeed become the stuff of metaphor.

The integrity and ingenuity Buff Monster brings to his mutant cast is a reflection of the skills and ethos he has inherited as an artist of many trades before he took up the studio practice of fine art full time. Germinated in the fandom of adolescence (it can hardly be a surprise looking at his Melty Misfit series that he remains nothing less than a scholar on the history of Garbage Pail Kids), sparked to life during his first forays as a graffiti artist growing up in Hawaii, honed by his tenure as an art director for magazines out in Los Angeles, driven by the fierce energies of a metal soundtrack that has been playing incessantly at high volume in the artist's head for decades now, and deeply motivated by the populist lessons of street art and artist's toys to be as accessible and friendly as their twisted little souls can let them be, Buff's belligerent brood of fabulous freaks have come to New York like a pack of bizarre aliens at once unmistakably outré and uncannily familiar.

I look at this motley lot now, loitering on our street corners, making homes on our shelves, and standing just outside the hallowed gates of the art world's cultural capital gaping big-eyed and drooling at this society of the spectacle, and wonder how they might fit it. This town is supposed to be the very crucible of America's great melting pot, and Buff Monster's deranged demonology comes pretty much half-melted already. We like strangeness here, oddity being some deviant form of commonality as we all register our collective sense of alienation, so my bet is that even if our cultural gatekeepers eventually realize that such riffraff is ill-suited for the politesse of highbrow aesthetics and kicks them out on their bright pink asses, no one will ever forget that now, at this very moment in time, they are the life of the party.

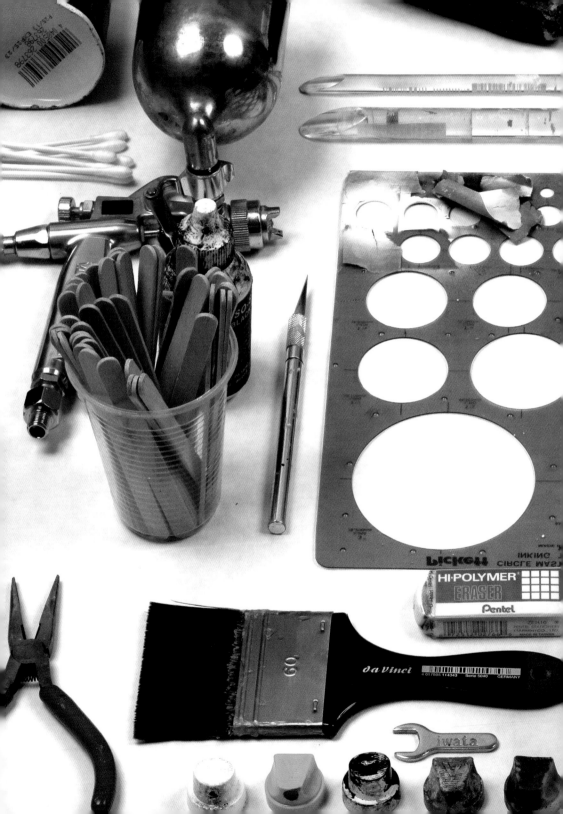

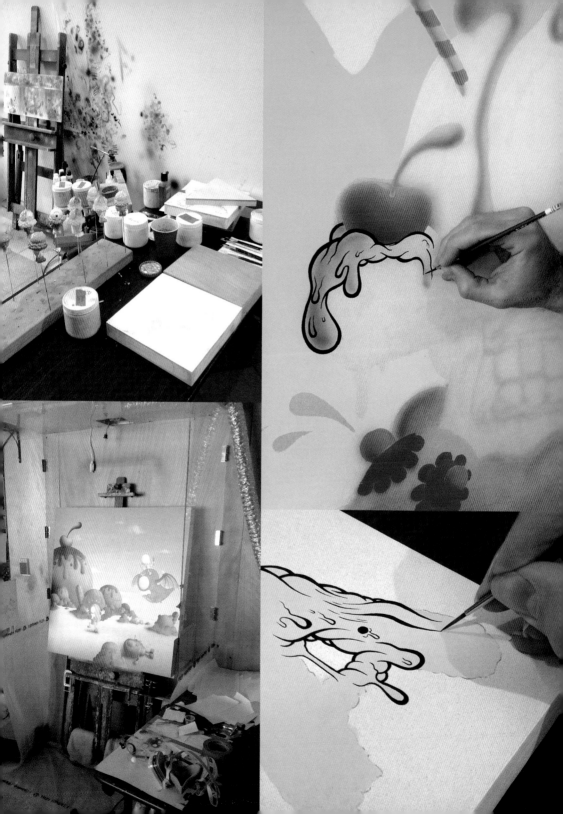

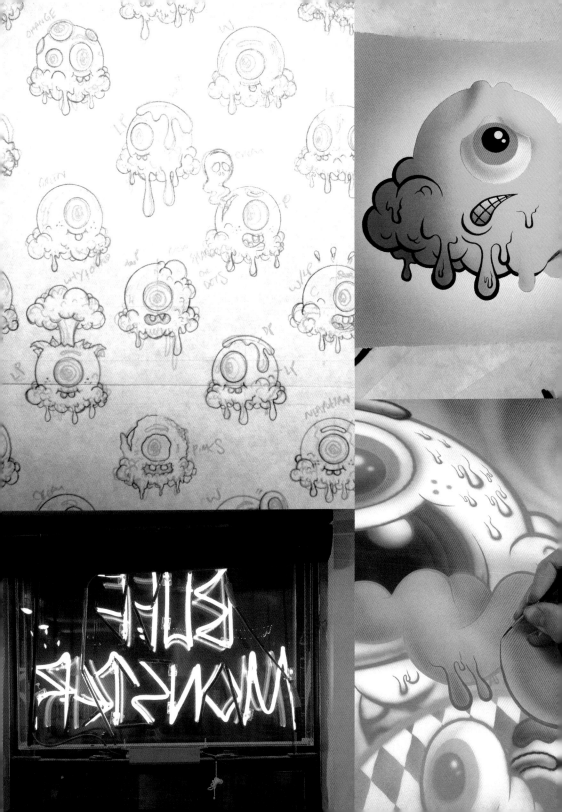

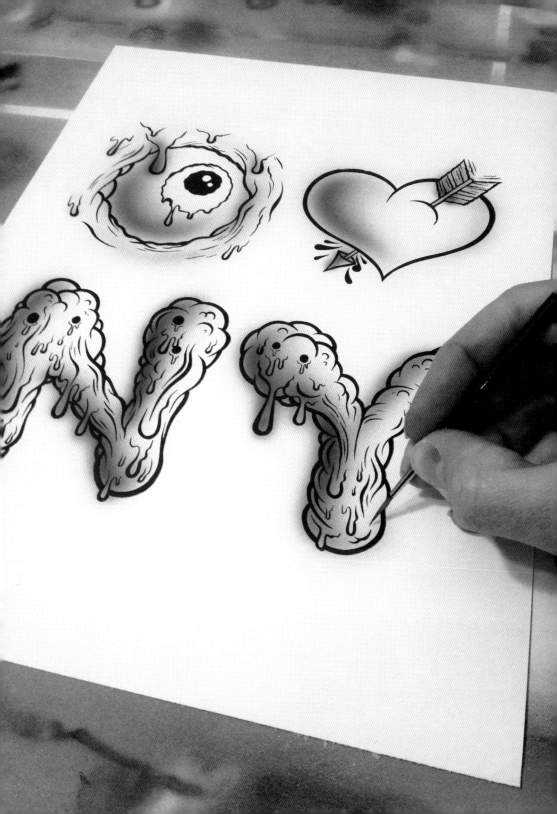

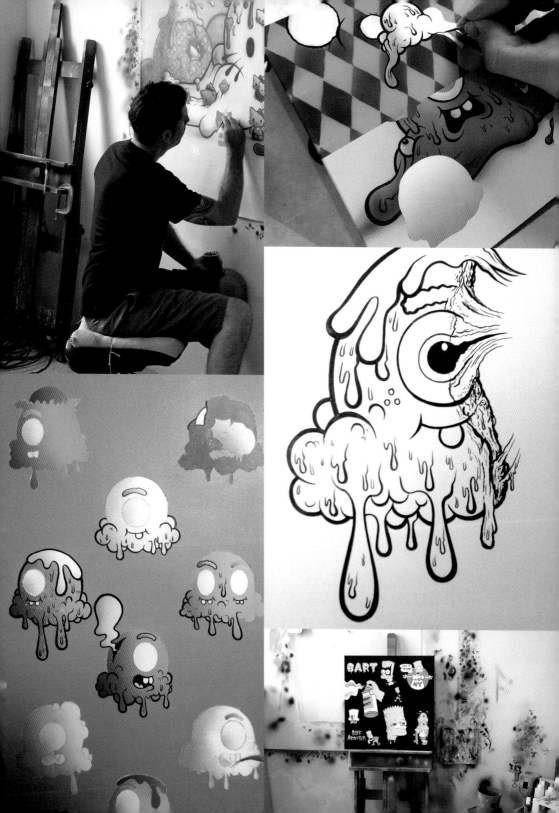

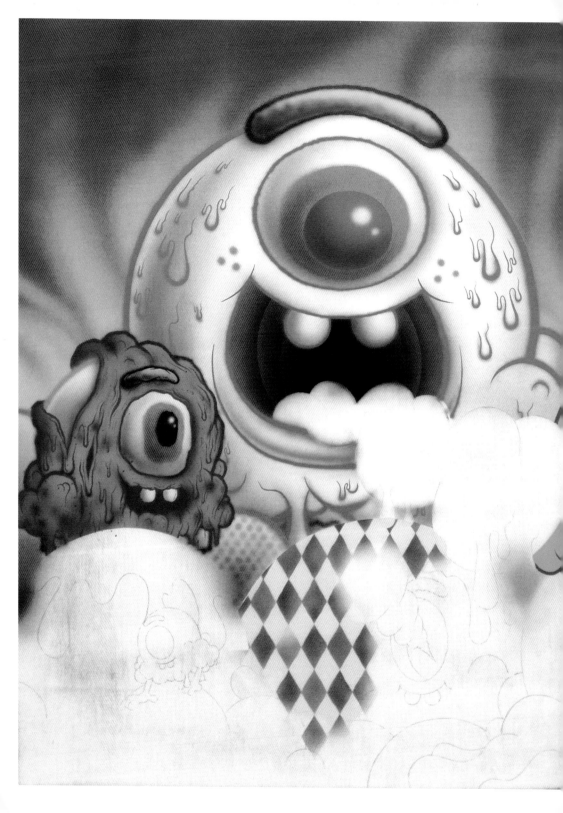

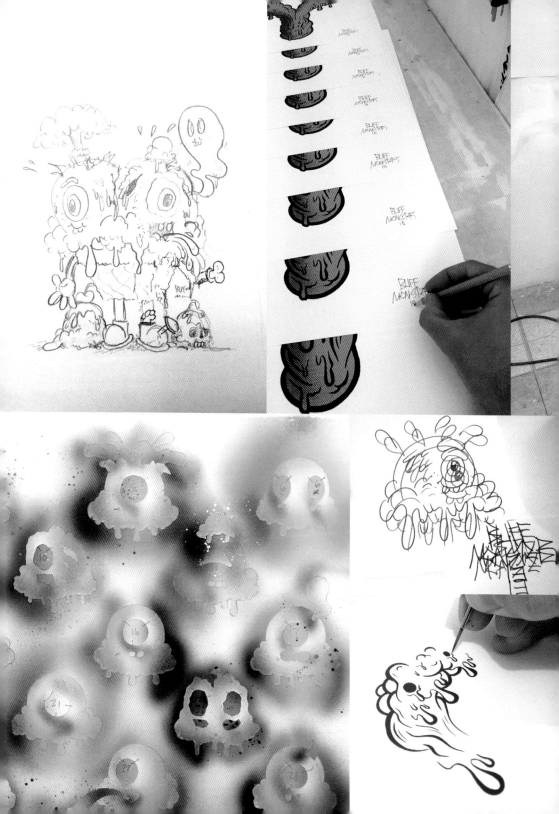

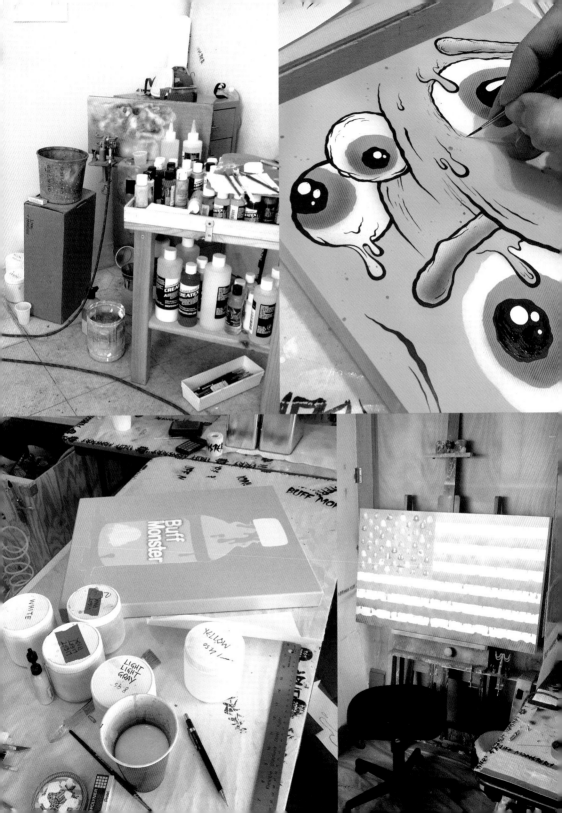

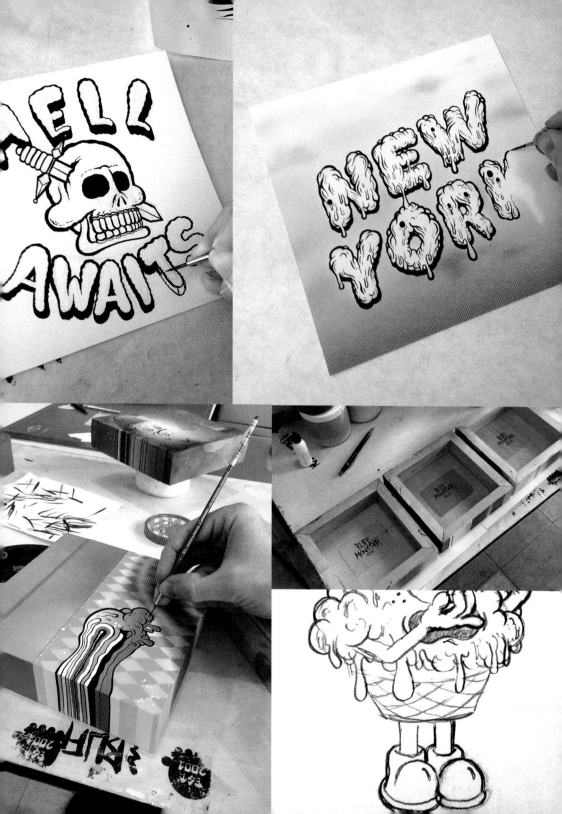

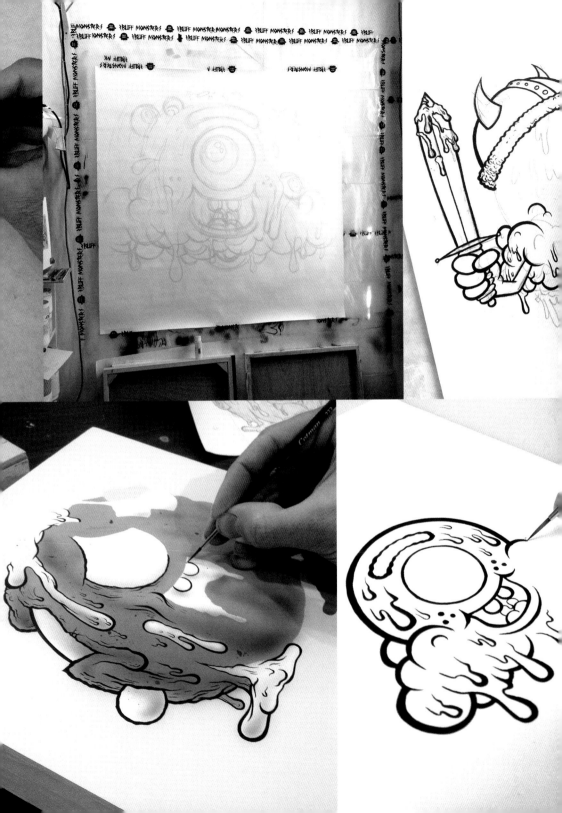

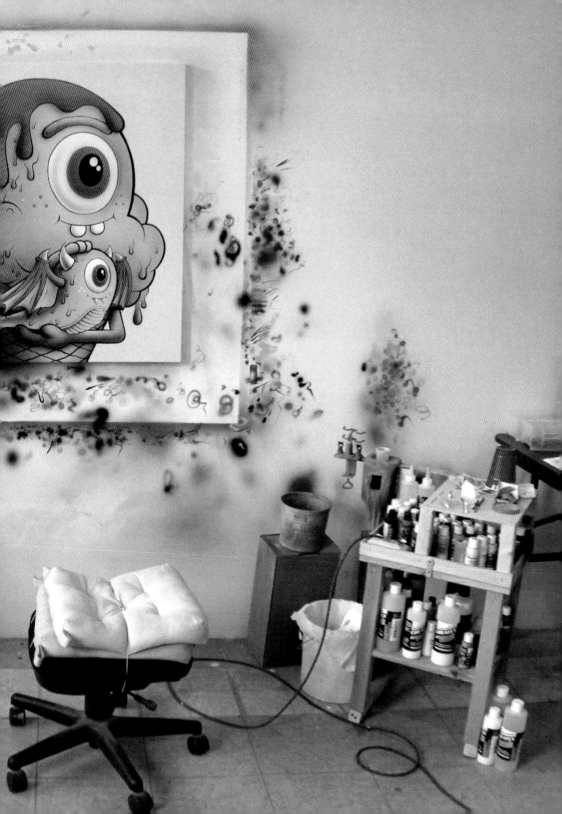

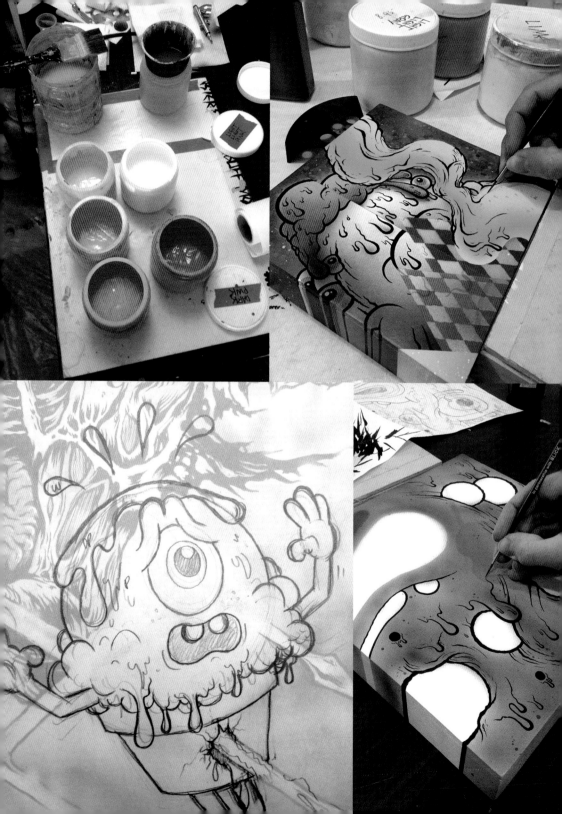

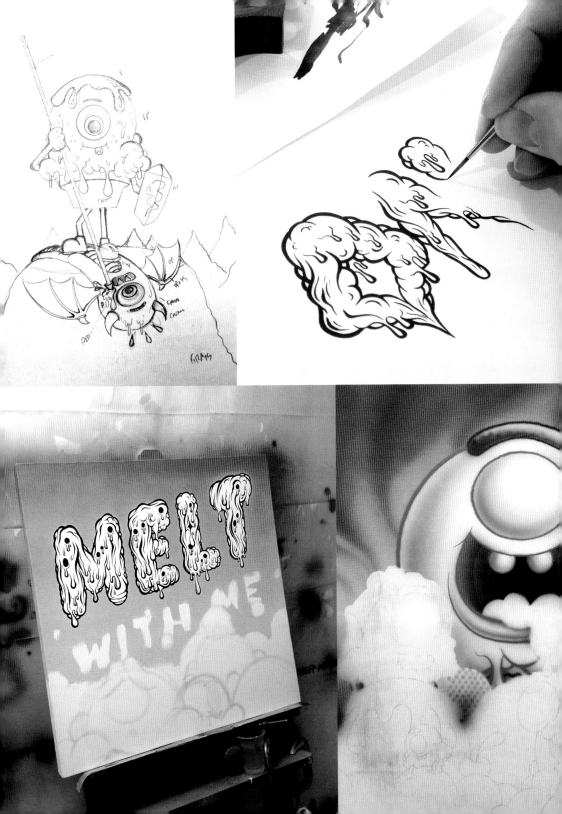

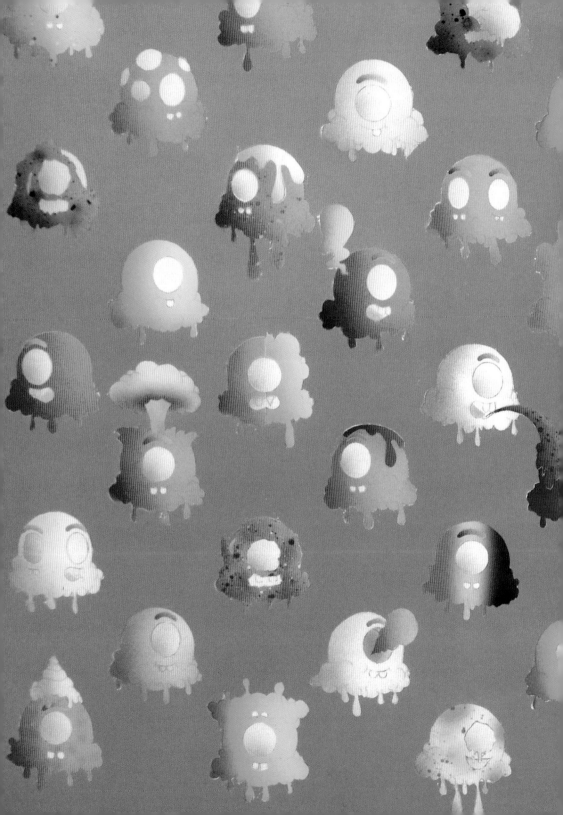

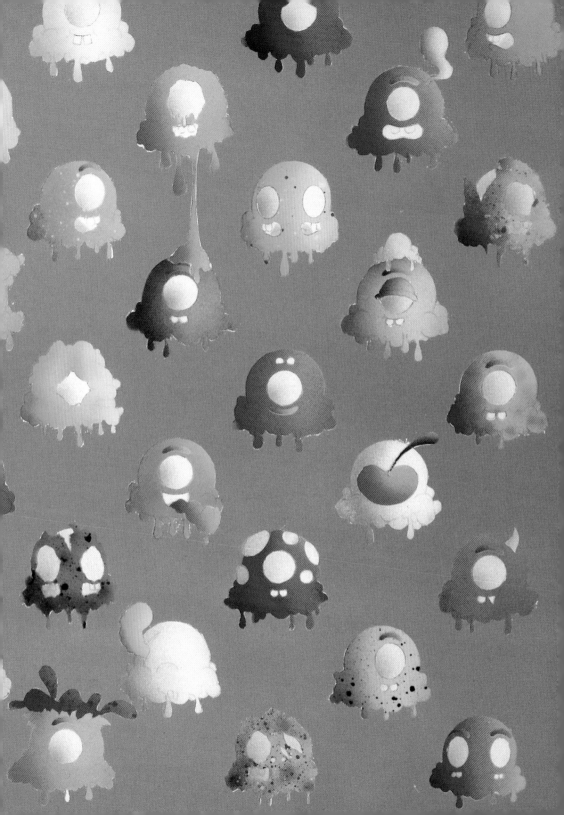

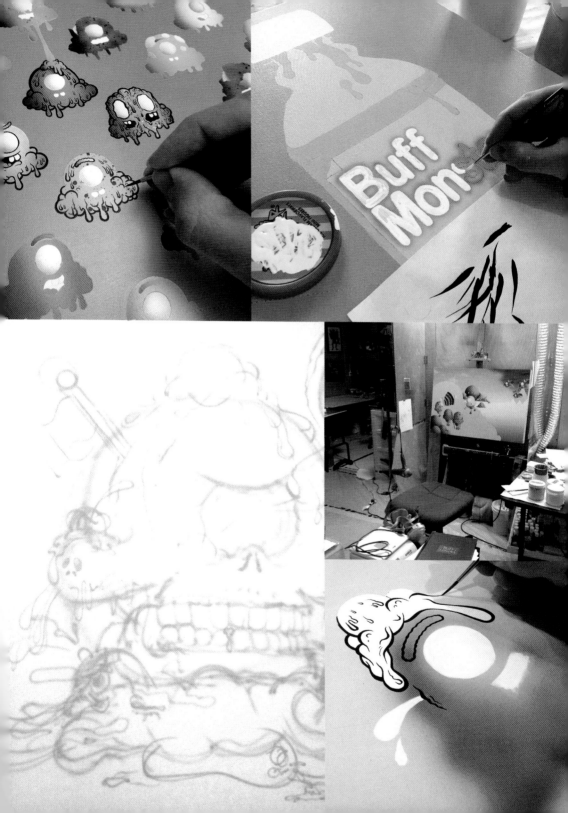

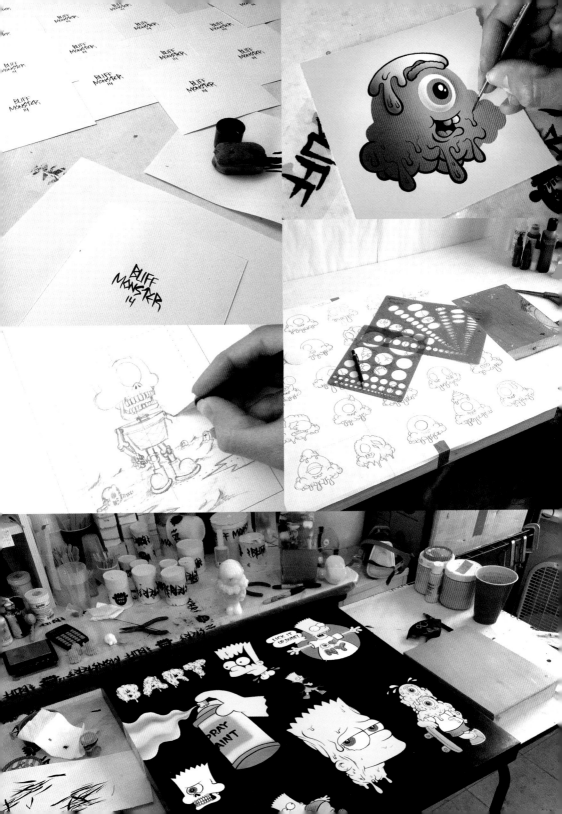

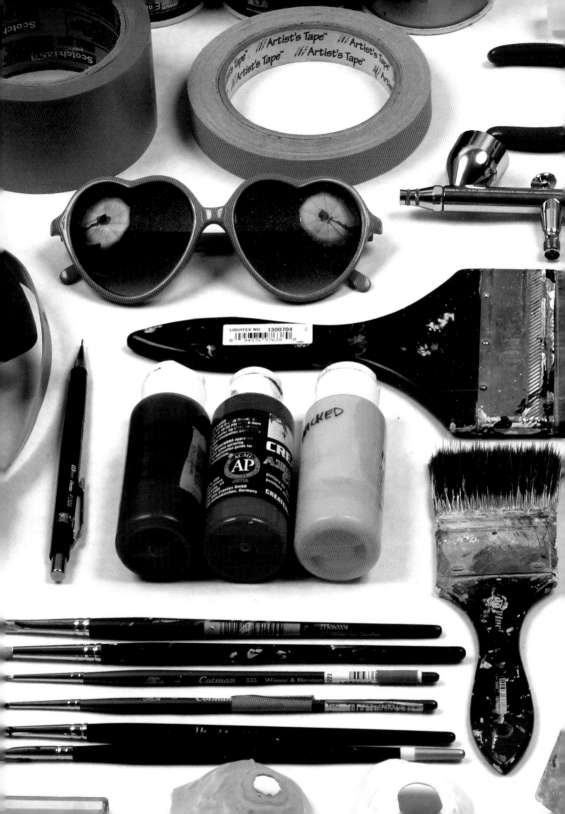

Birth of a Zombie, 2012
Acrylic on cradled birch panel, 16x16"

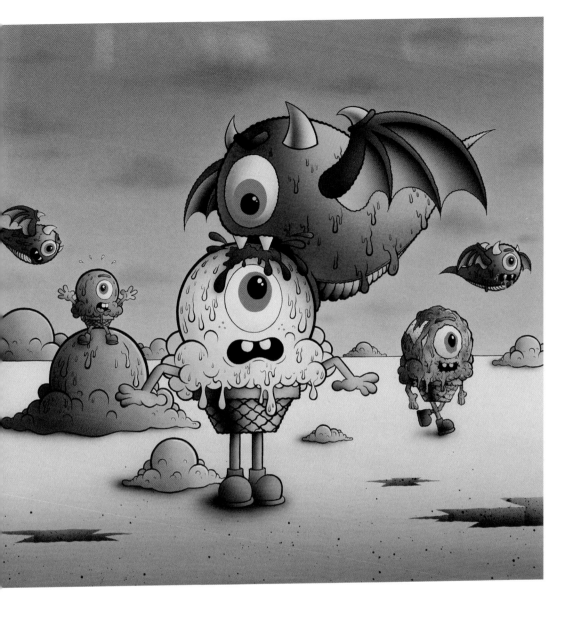

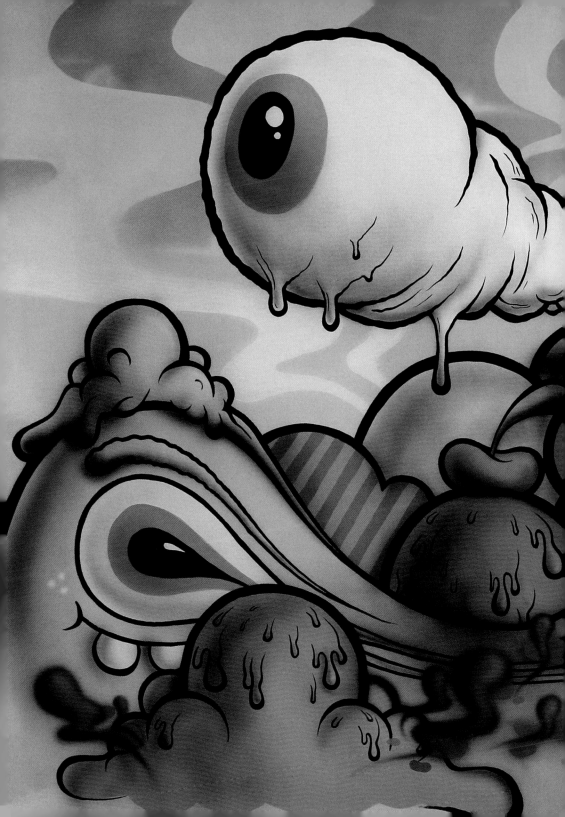

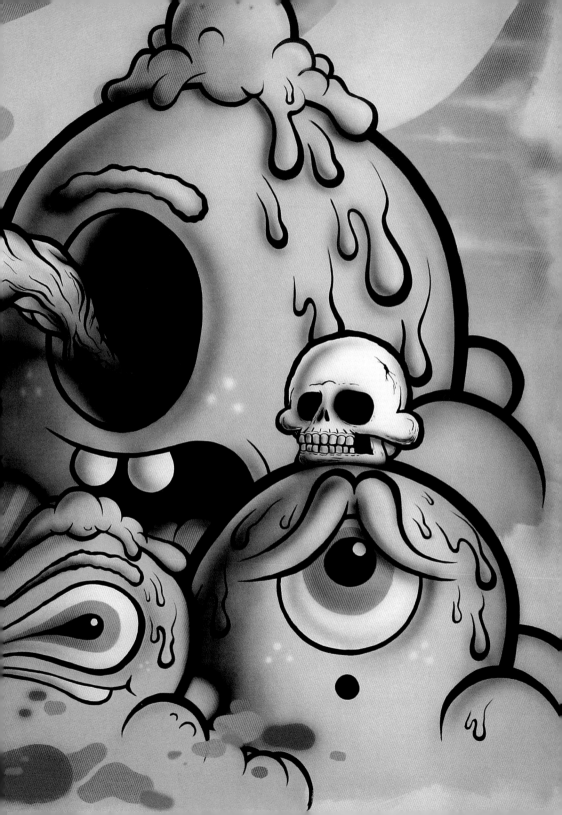

Previous Spread:
Untitled, 2014
Acrylic on canvas, 48x36"

The Demon Tamer, 2014
Acrylic on canvas, 36x36"

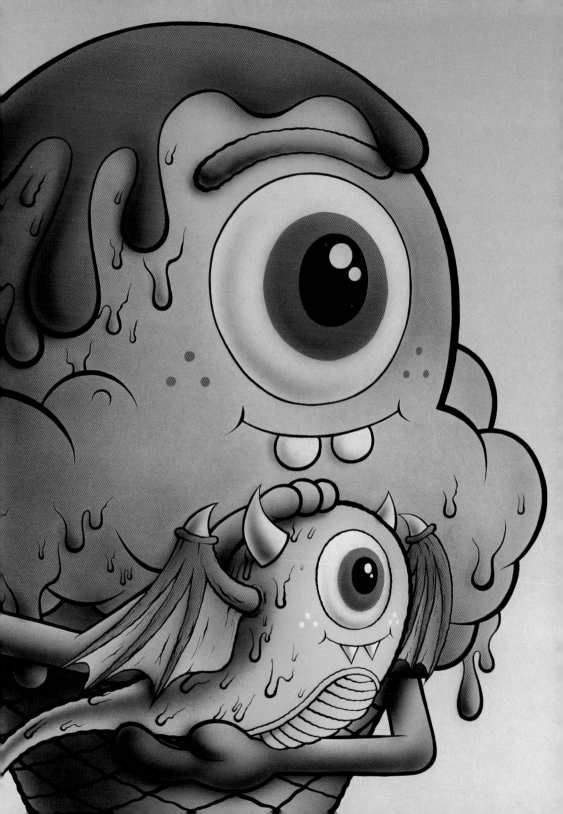

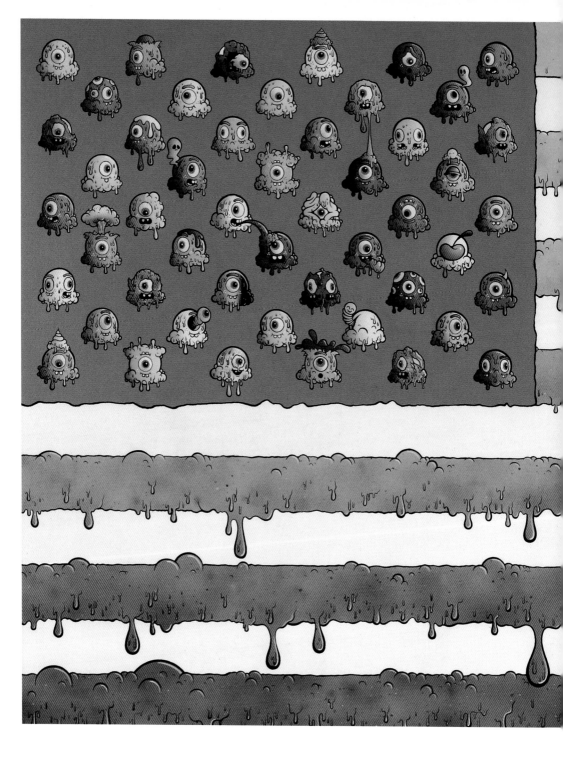

Previous Spread:
Untitled (American Flag), 2014
Acrylic on cradled birch panel, 40x24"

At the Crossroads, 2012
Acrylic on cradled birch panel, 24x24"

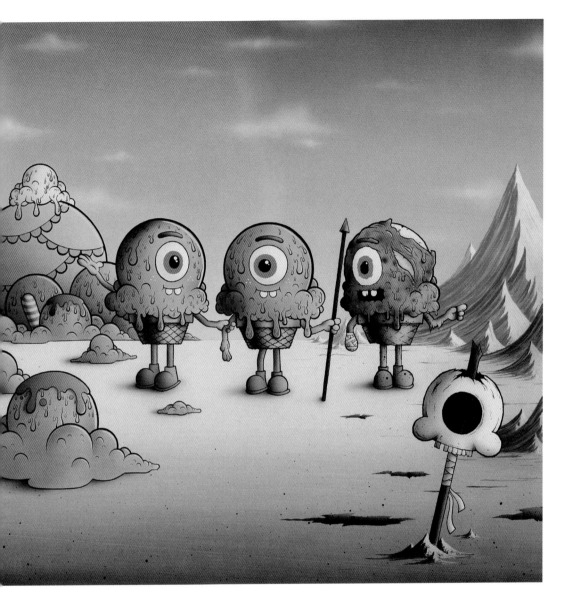

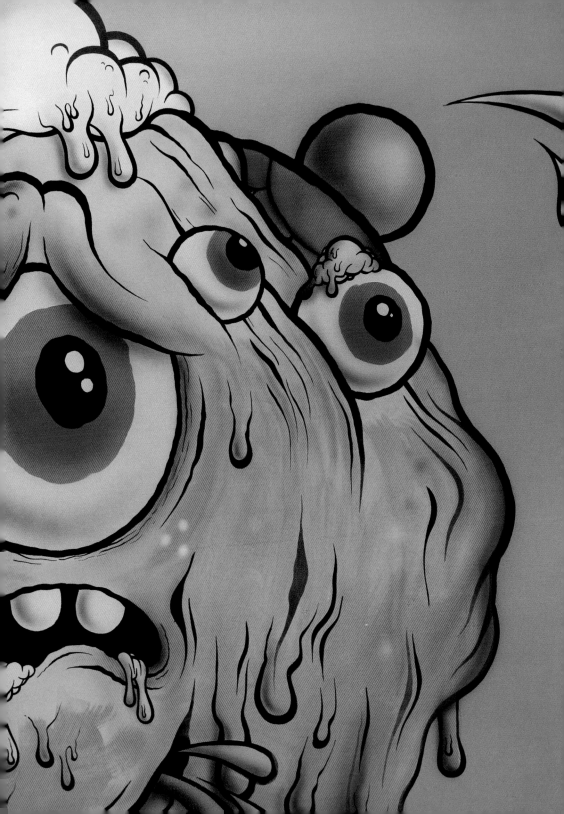

Untitled (Self-Portrait) (detail), 2014
Acrylic on canvas, 52x40"

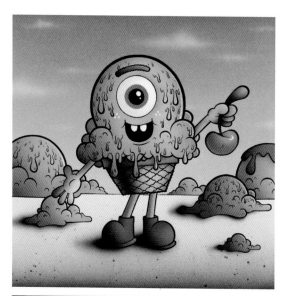

Top:
A Happy Cherry Picker, 2013
Acrylic on cradled birch panel, 10x10"

Above:
A Lonely Zombie, 2013
Acrylic on cradled birch panel, 10x10"

Right:
Resurrection of the Flesh, 2012
Acrylic on cradled birch panel, 36x36"

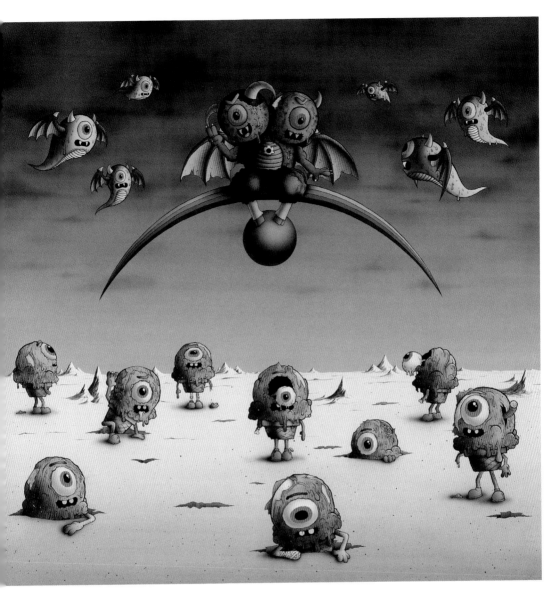

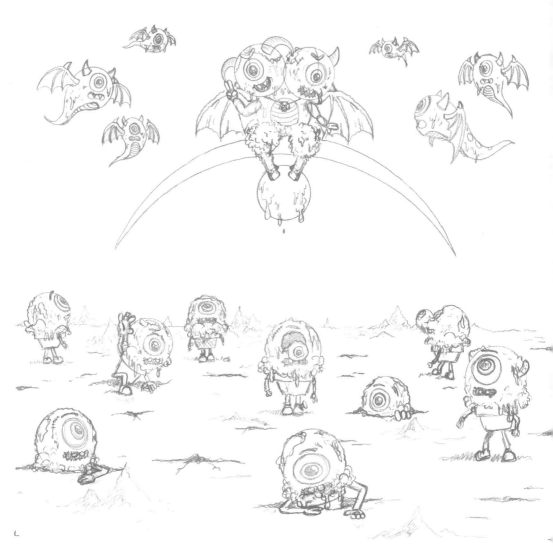

Above:
Resurrection of the Flesh (sketch), 2012
Graphite on paper, 6x6"

Right:
Resurrection of the Flesh (detail), 2012
Acrylic on cradled birch panel, 36x36"

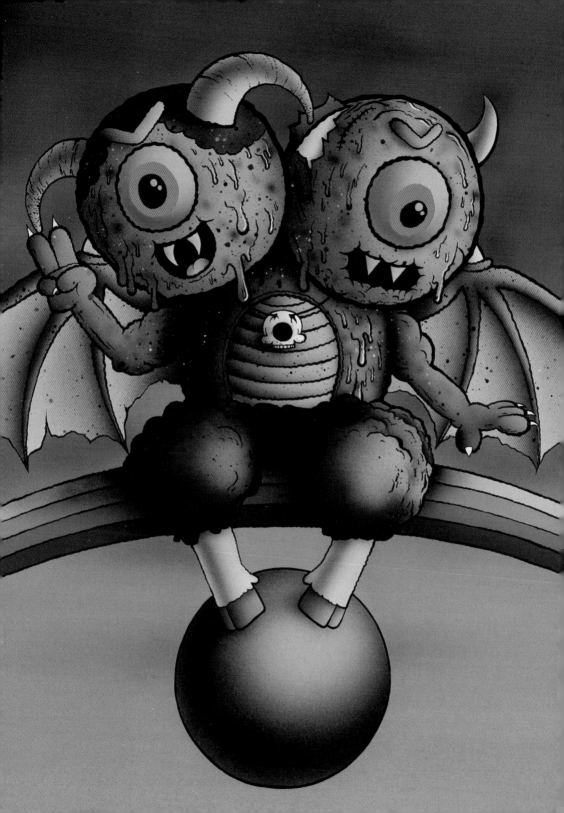

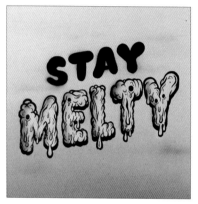

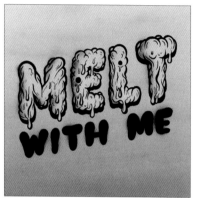

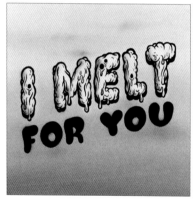

Top:
Stay Melty, 2013
Acrylic on watercolor paper, 5x5"

Above:
I Melt For You, 2013
Acrylic on watercolor paper, 5x5"

Right:
Melt with Me, 2015
Acrylic and spray paint on porcelain plate, 13" diameter

Top:
Melt With Me, 2013
Acrylic on watercolor paper, 5x5"

Above:
Born to Melt, 2013
Acrylic on watercolor paper, 5x5"

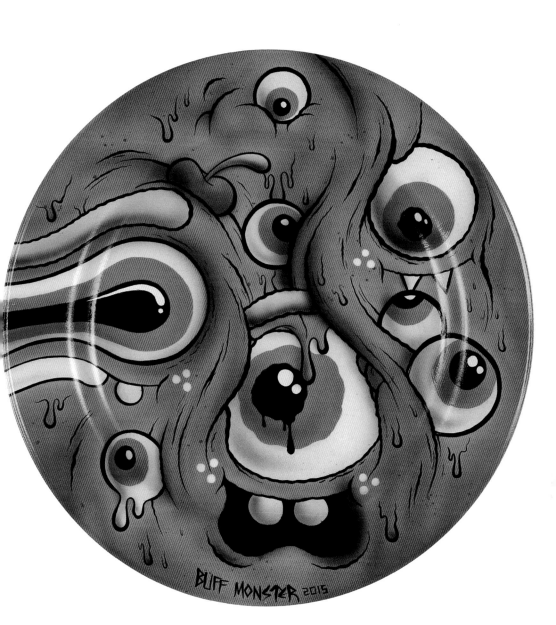

A Trophy, 2014
Acrylic on canvas, 36x36"

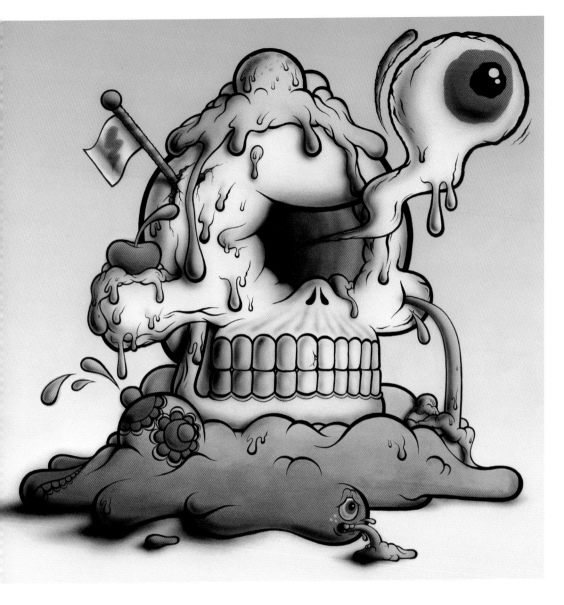

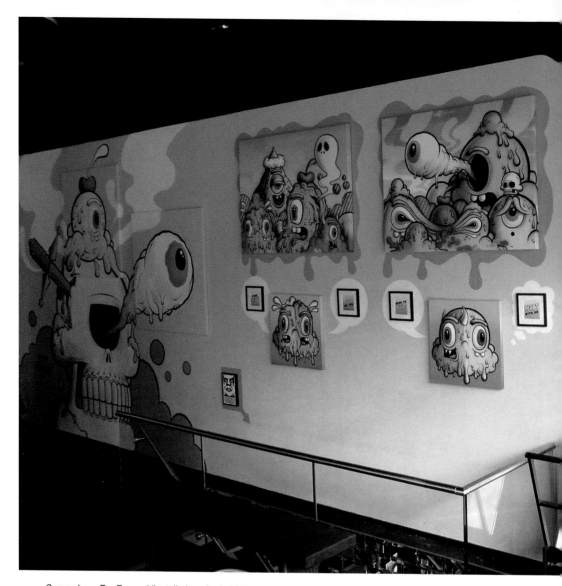

Somewhere Far Beyond (installation view), 2013
Toykio, Dusseldorf Germany

Right:
Untitled, 2013
Acrylic on canvas, 24x24"

Untitled, 2013
Acrylic on canvas, 24x24"

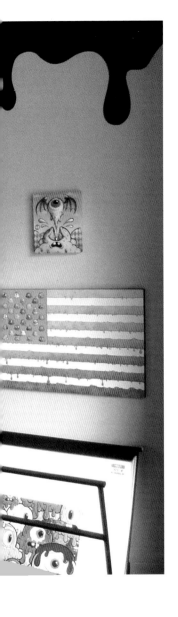

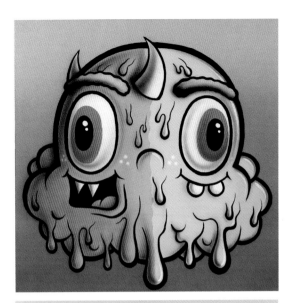

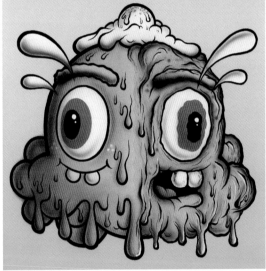

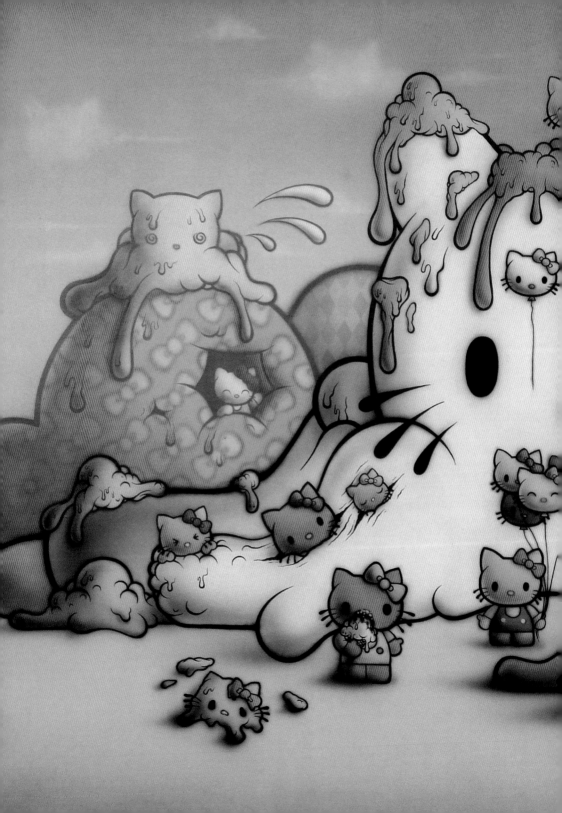

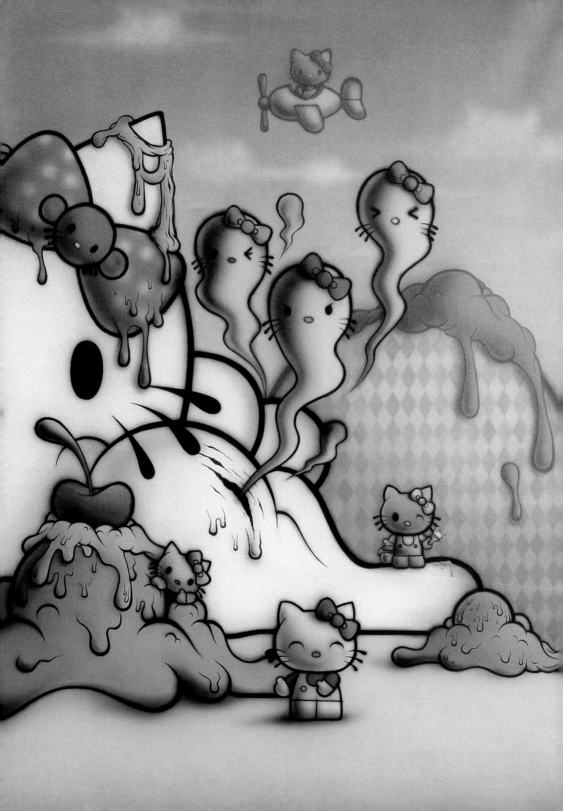

Previous Spread:
Melty Kitty Dream, 2014
Acrylic on canvas, 48x36"

Delirium, 2013
Acrylic on cradled birch panel, 24x24"

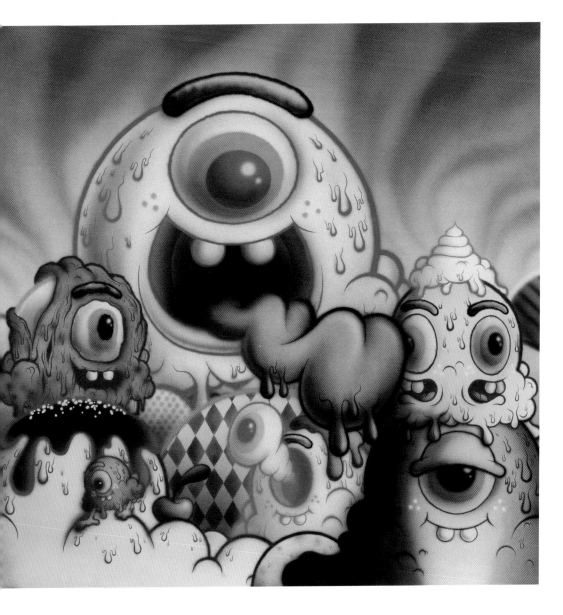

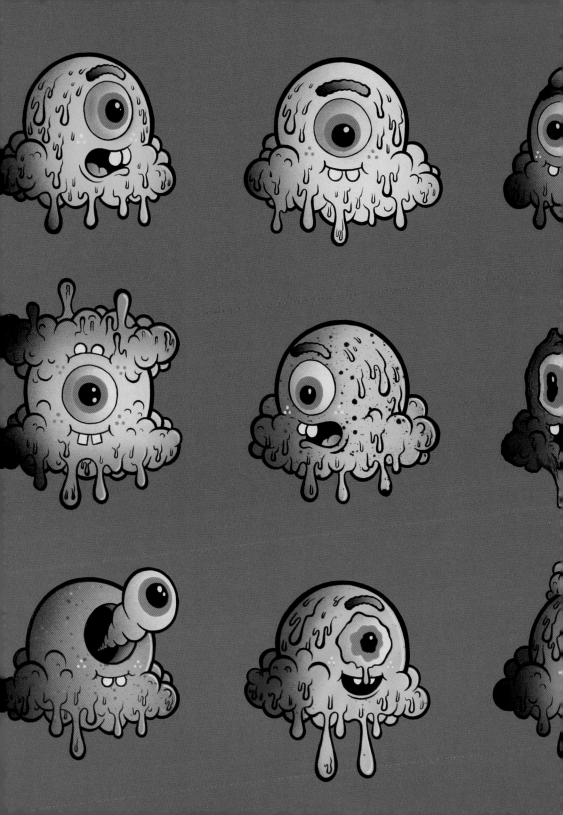

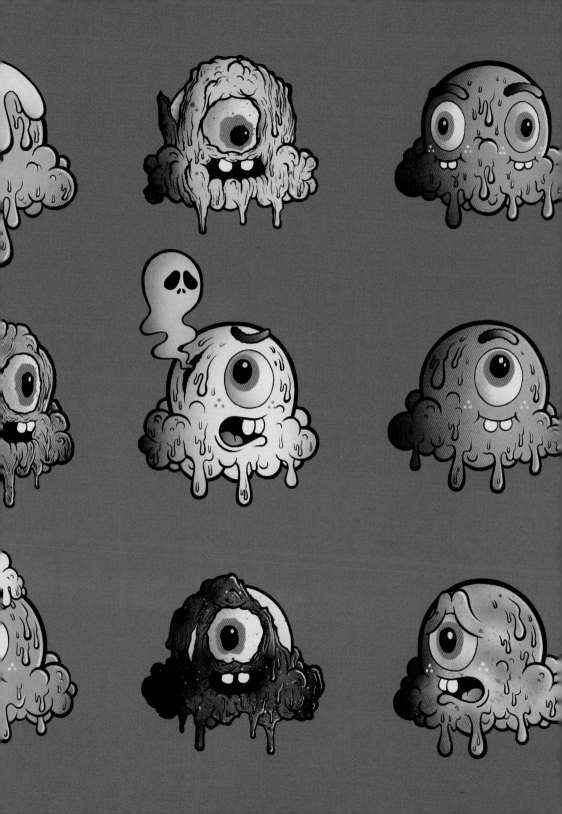

Previous Spread:
Motley Melties (detail), 2013
Acrylic on cradled birch panel, 24x24"

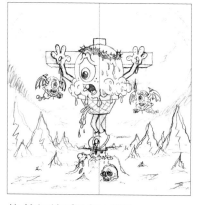

He Melted for Our Sins, 2012
Acrylic on cradled birch panel, 16x16"

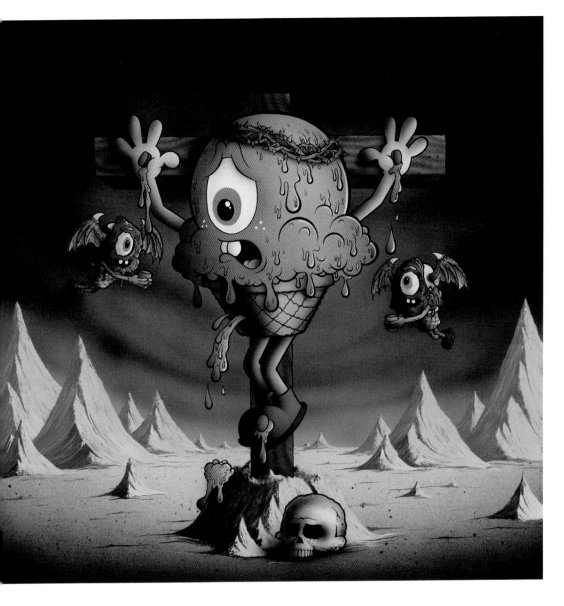

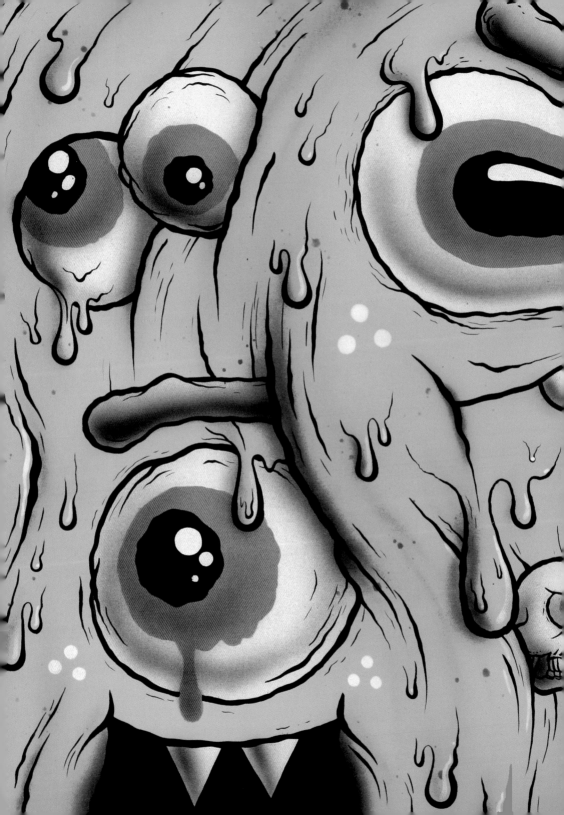

Untitled, 2015
Acrylic on cradled birch panel, 10x10"

The Coned Crusader Pierces a Demon, 2012
Acrylic on cradled birch panel, 16x16"

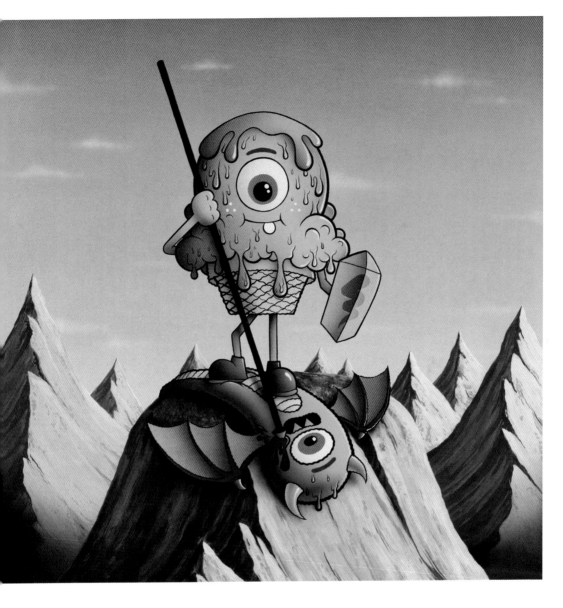

Number of the Beast (detail), 2013
Acrylic on cradled birch panel, 24x24"

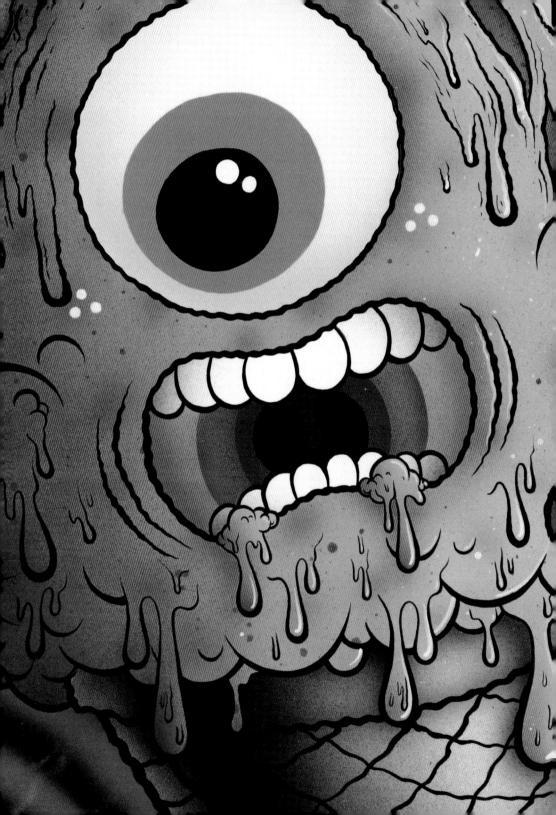

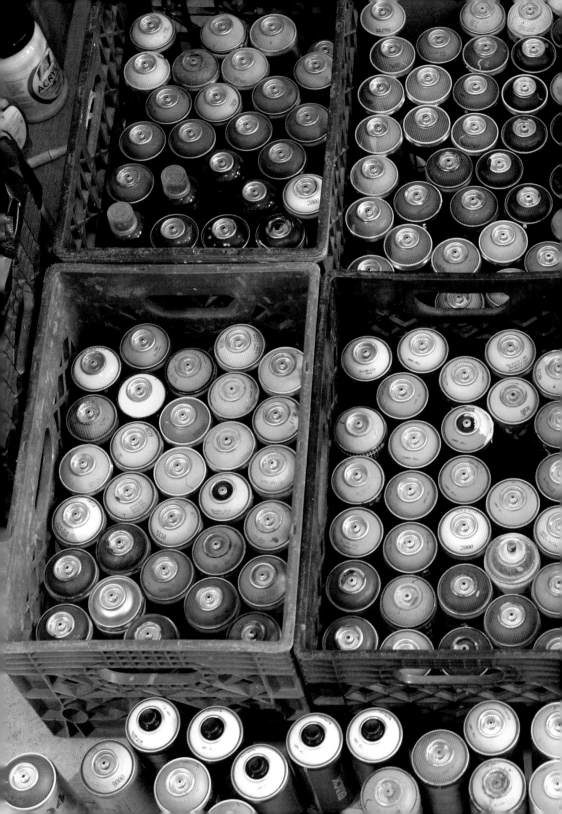

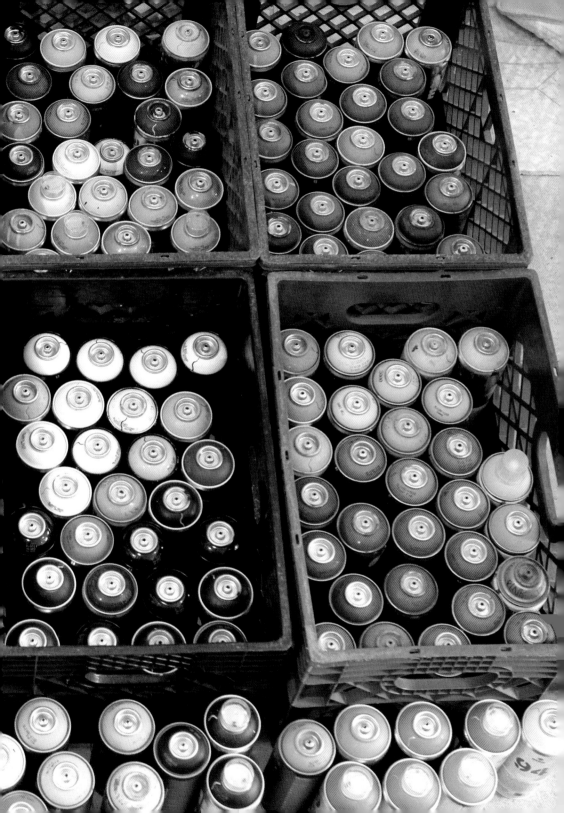

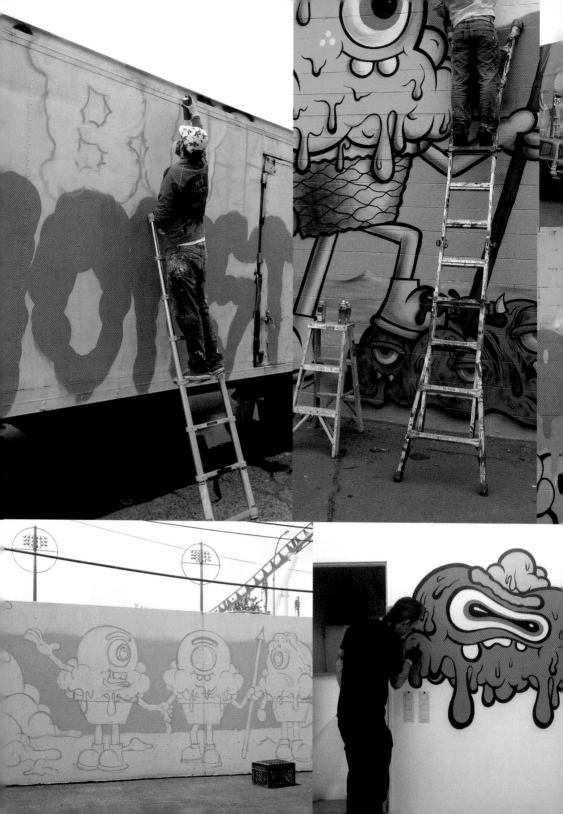

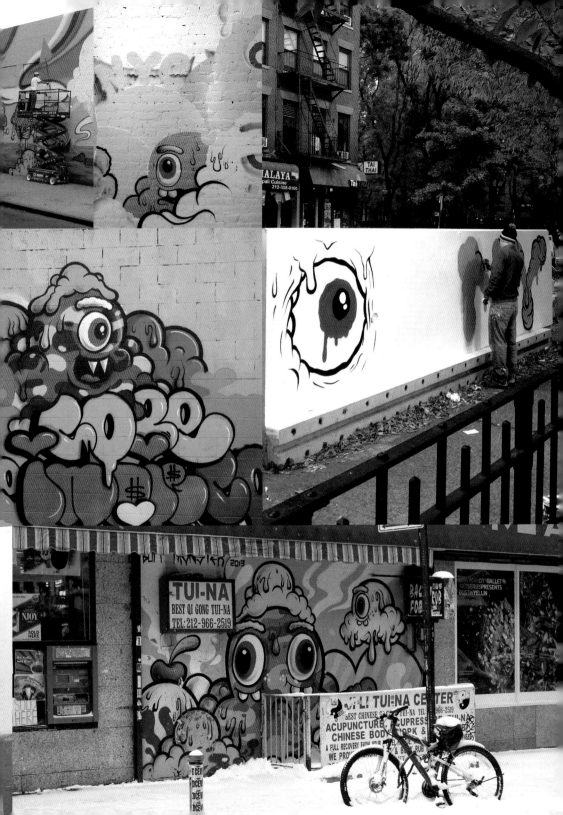

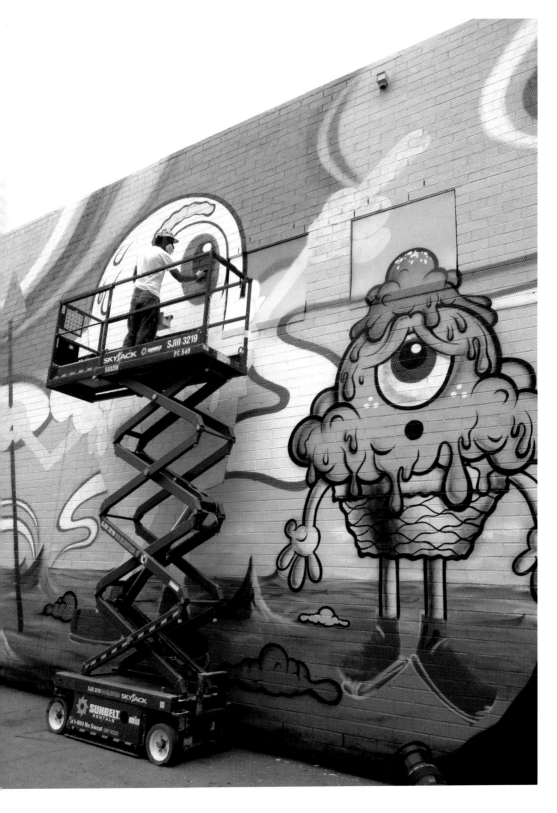

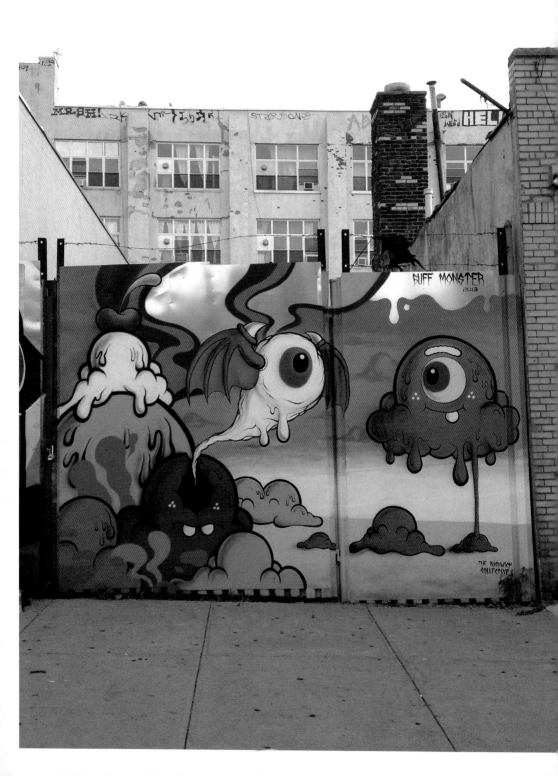

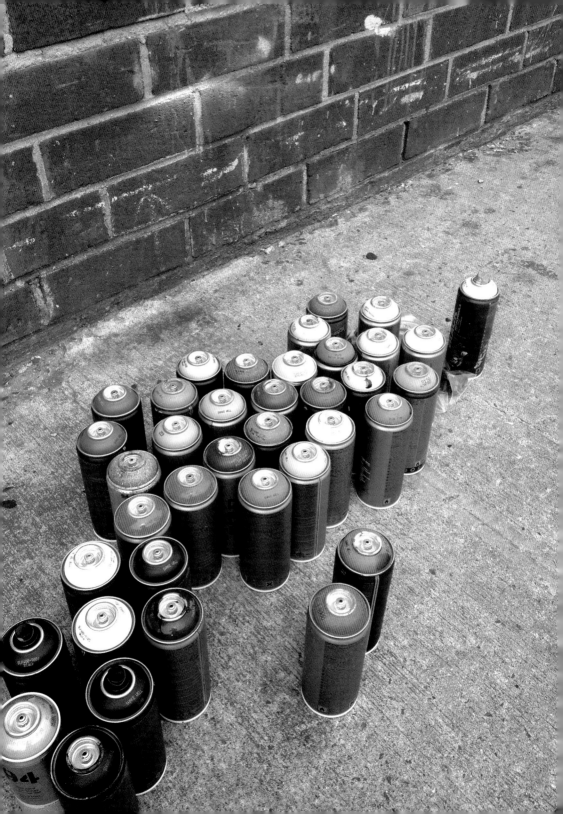

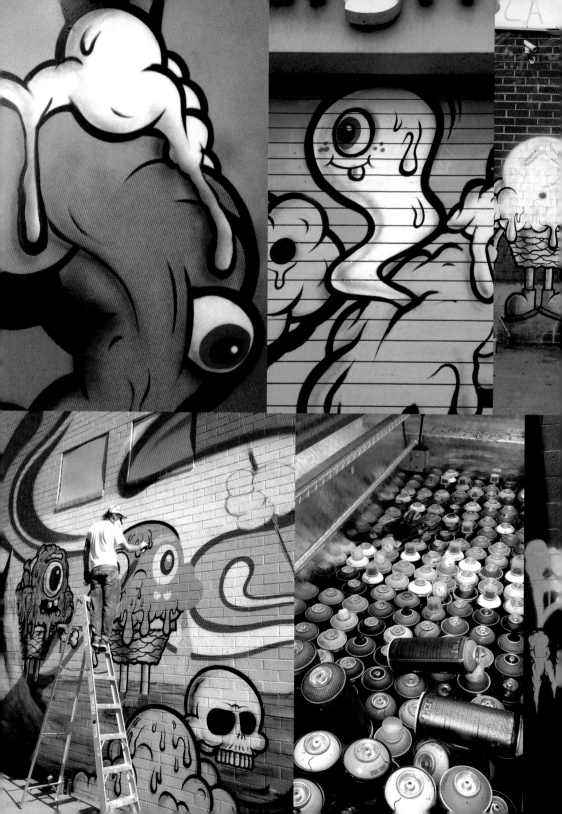

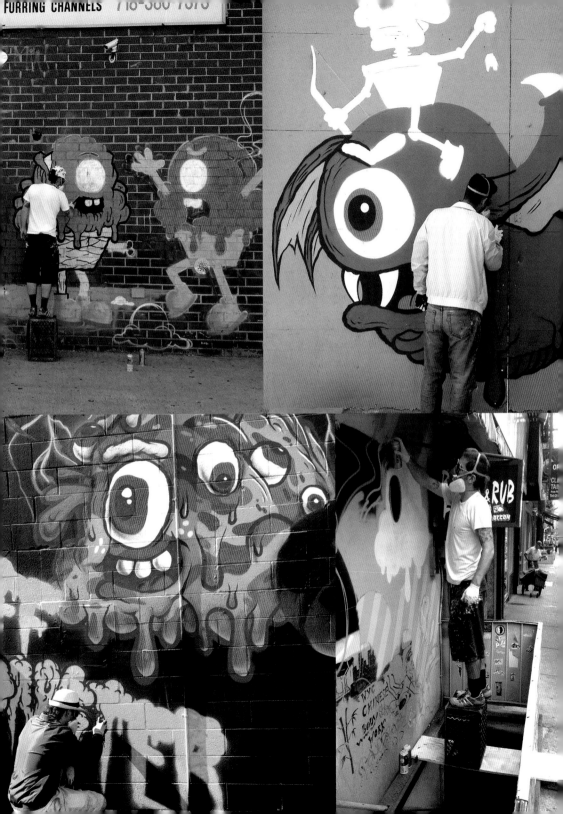

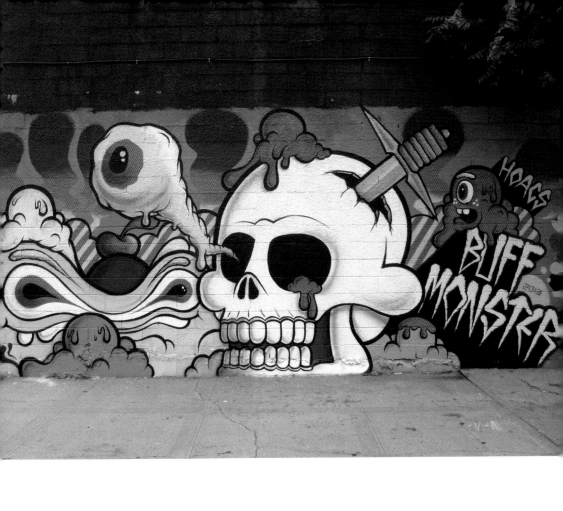

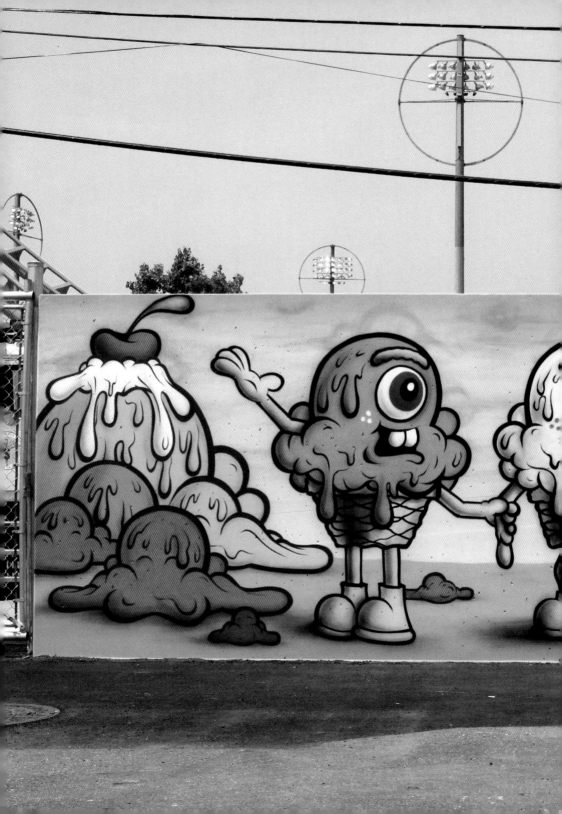

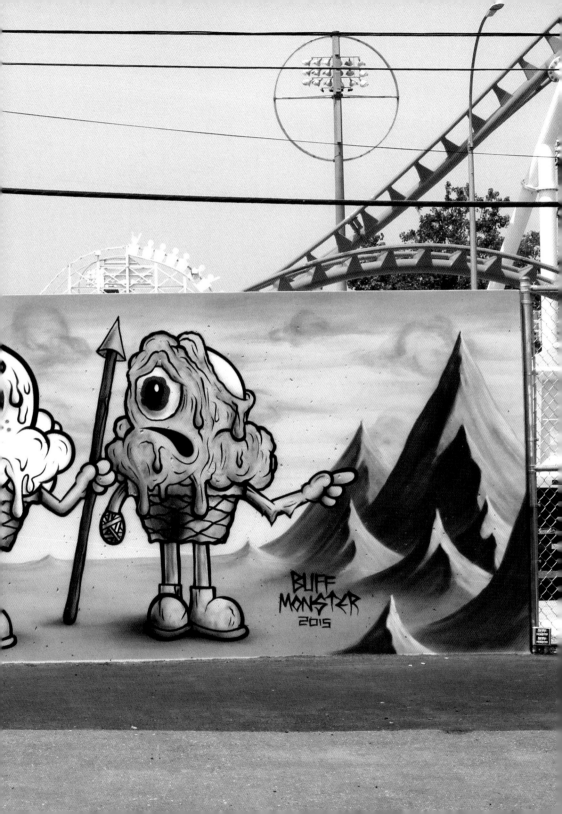

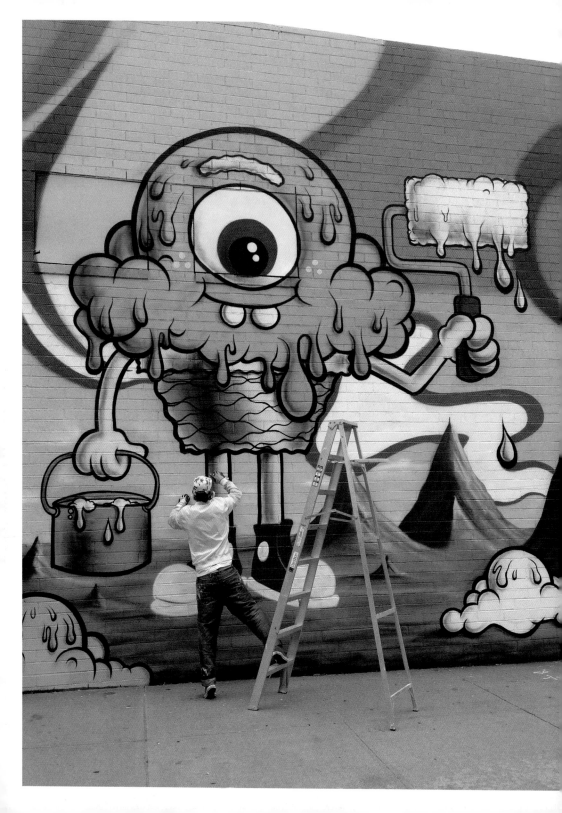

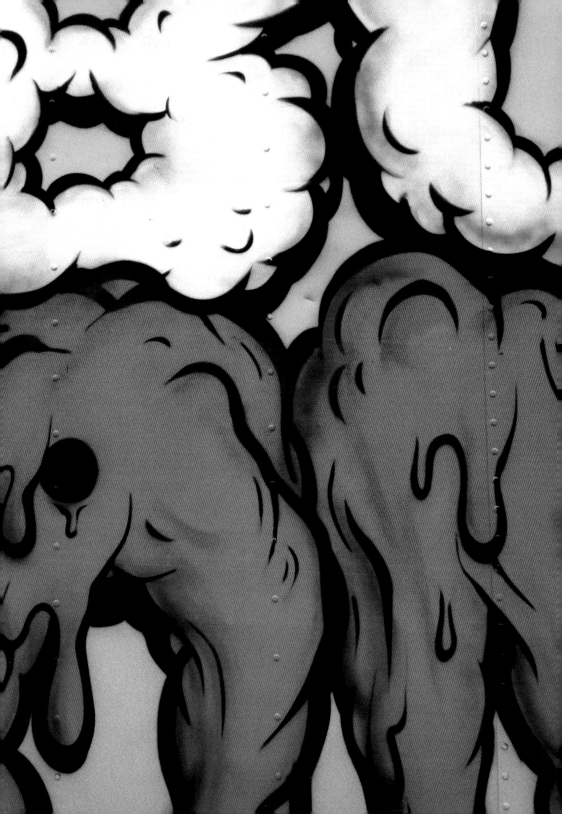

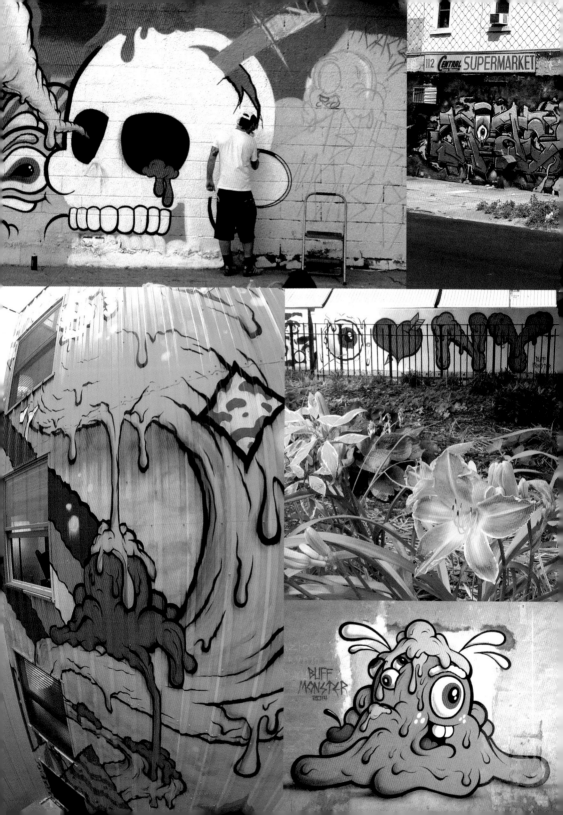

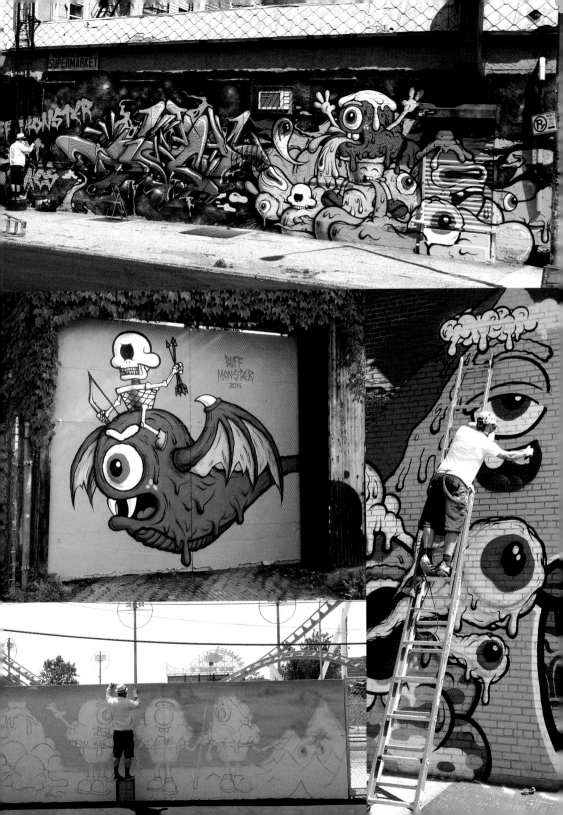

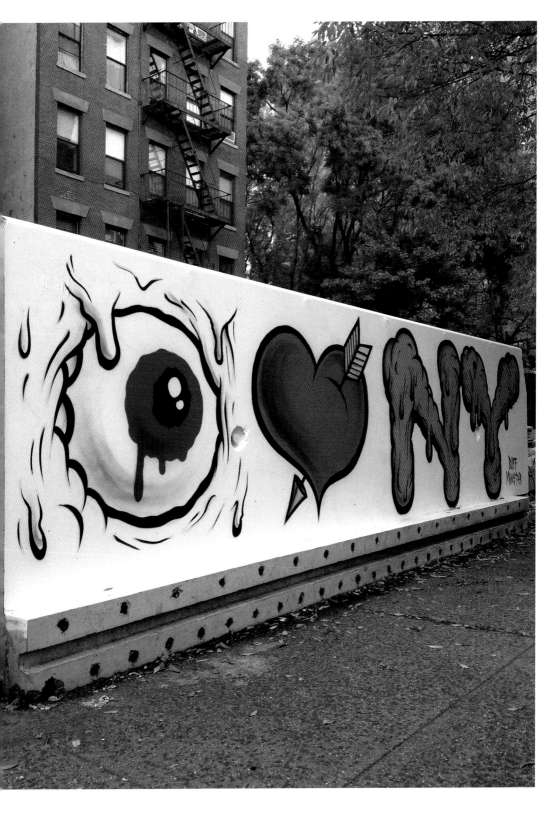

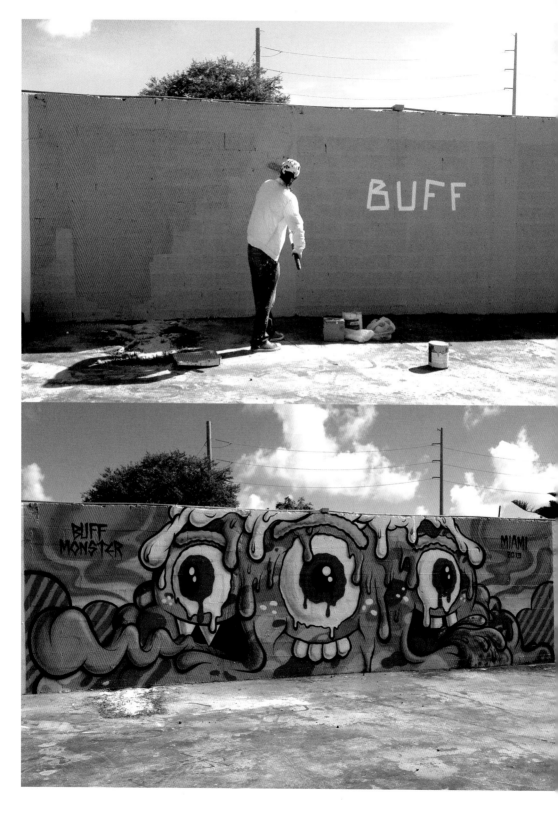

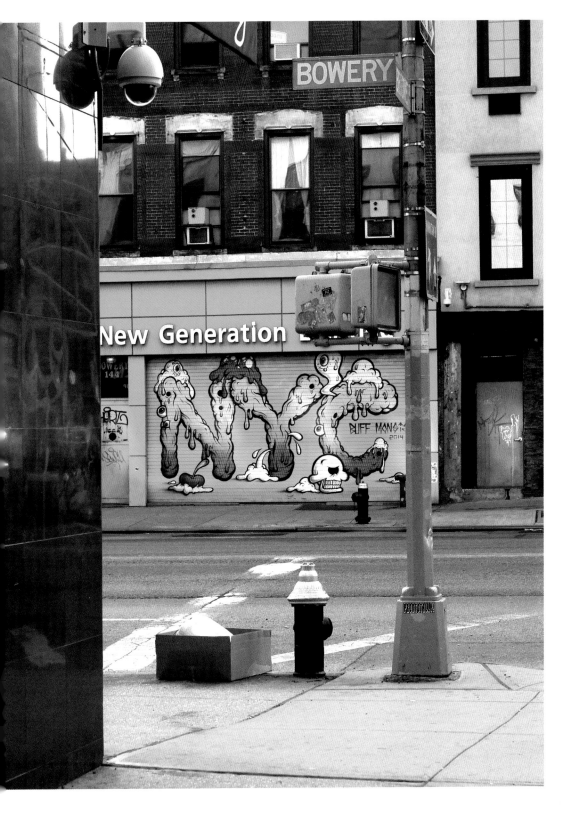

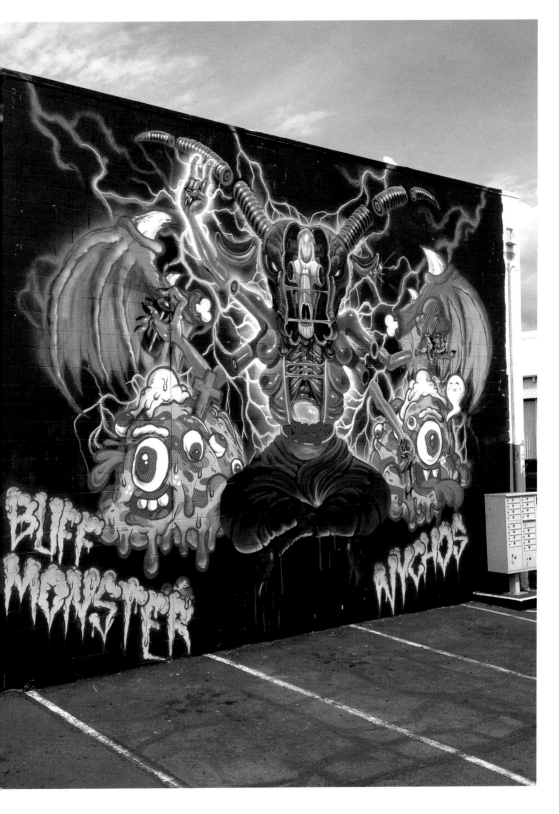

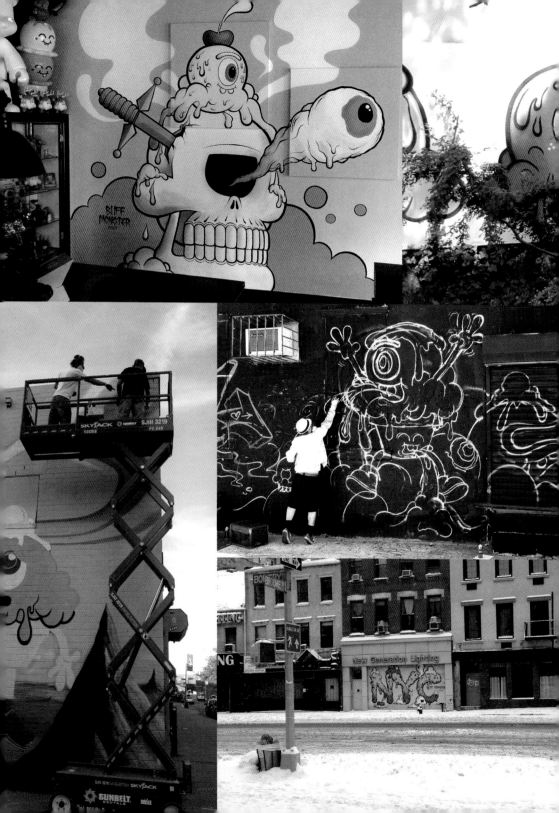

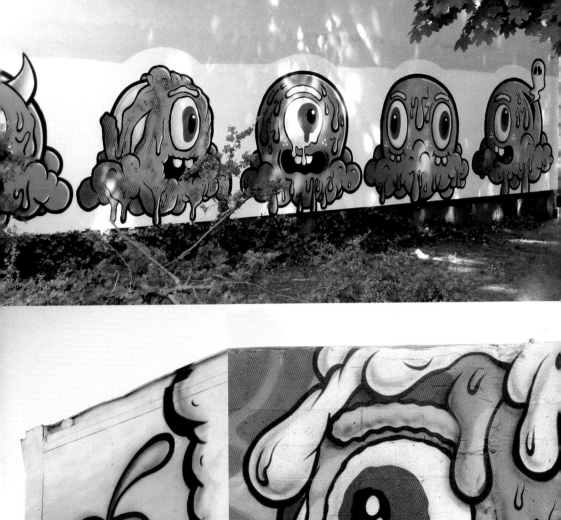
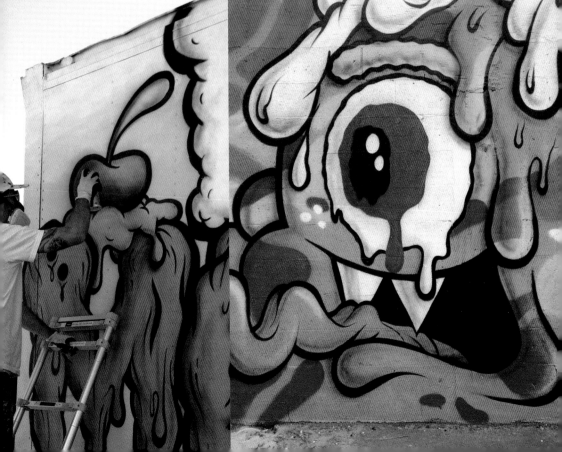

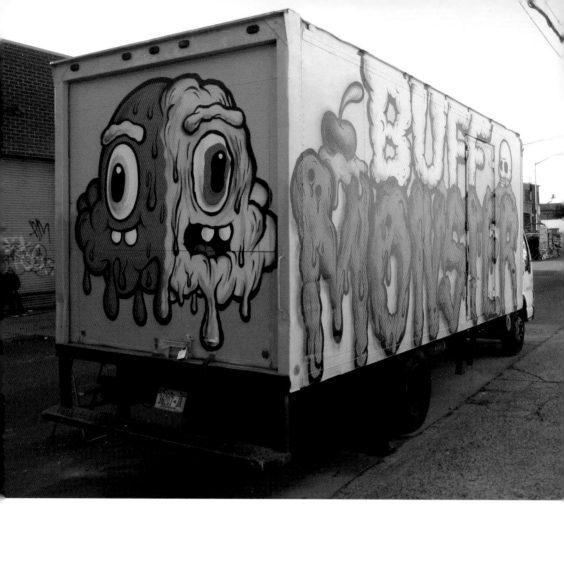

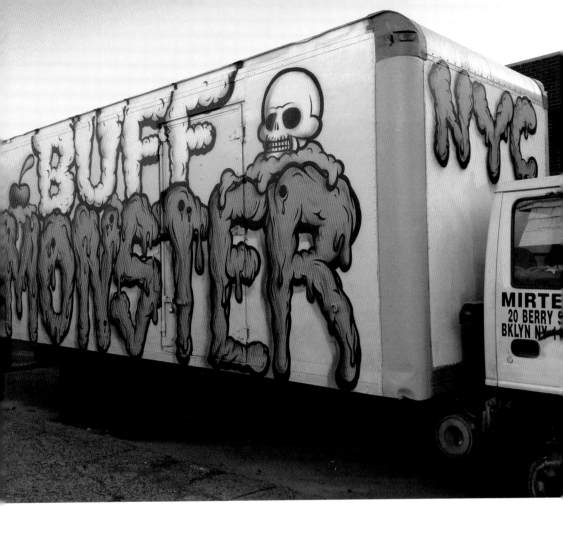

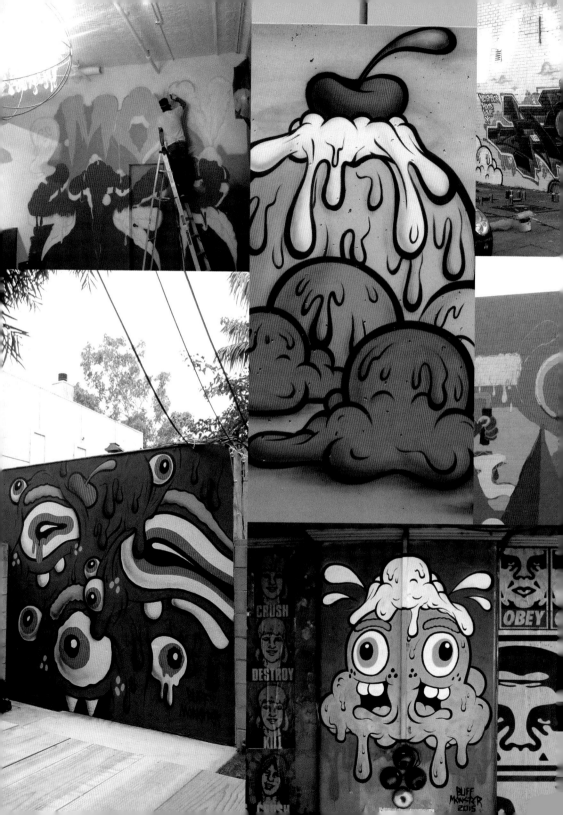

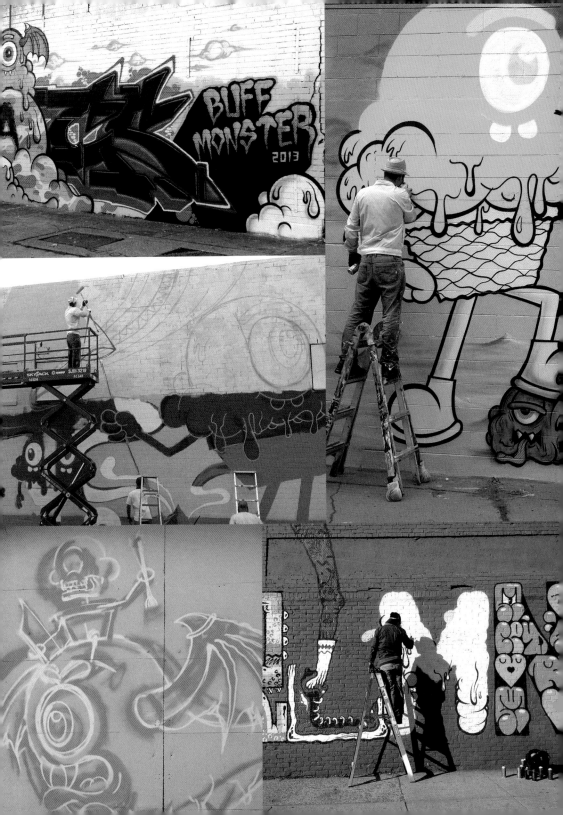

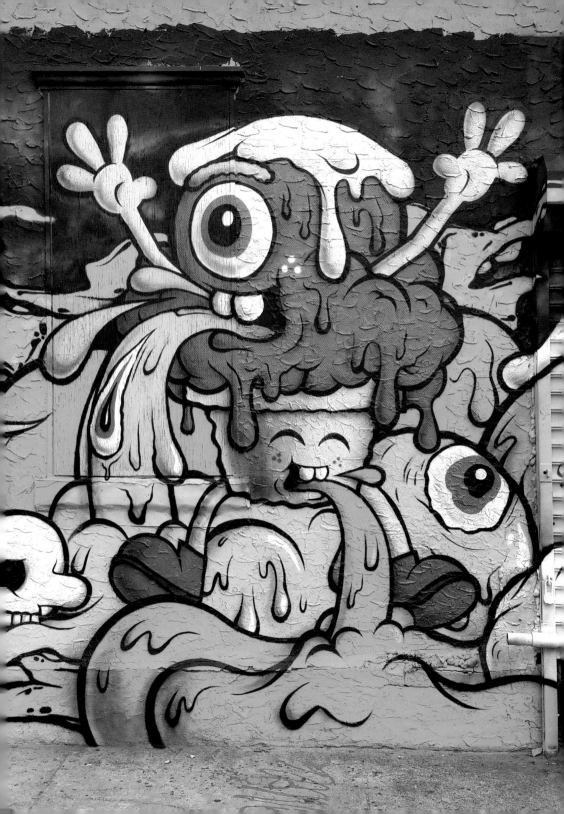

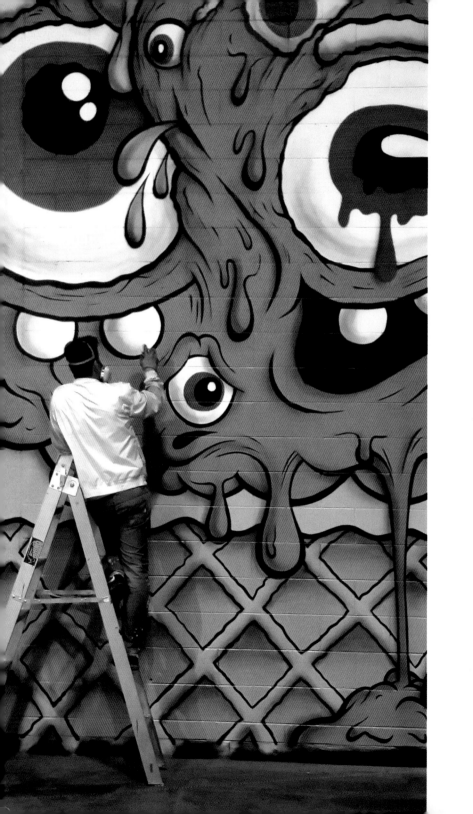

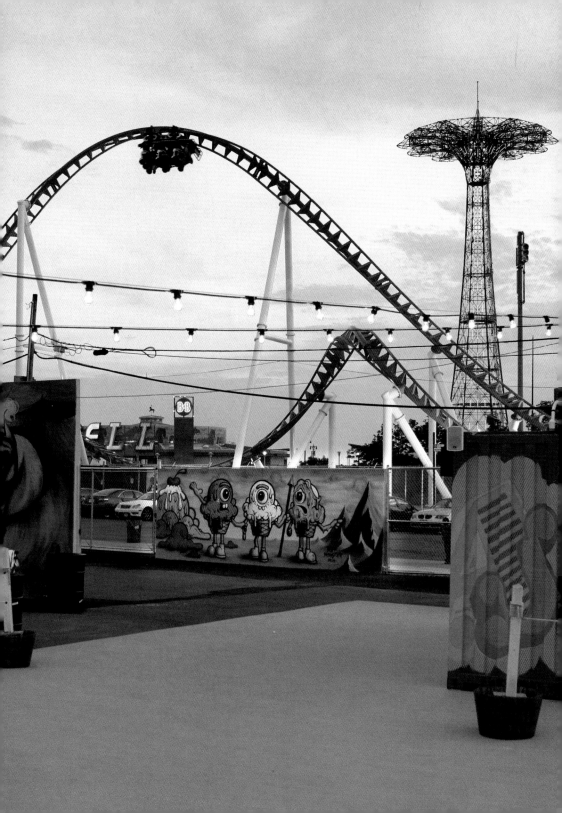

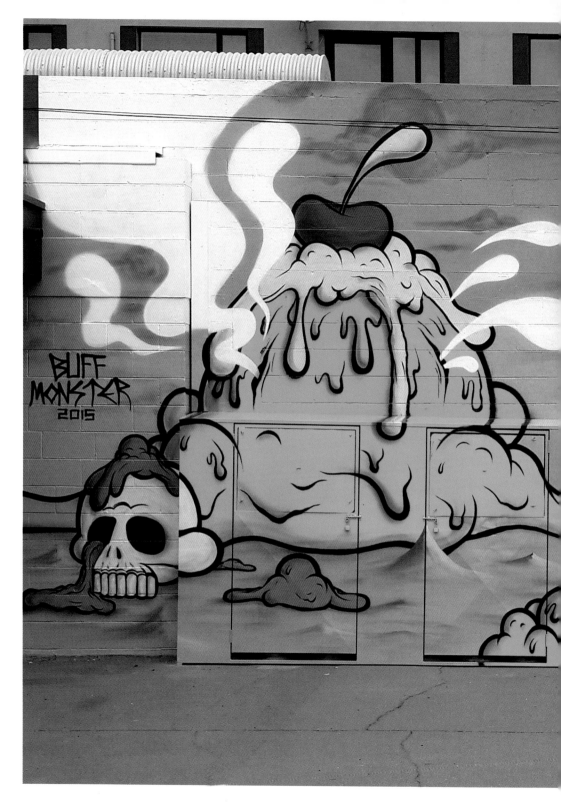

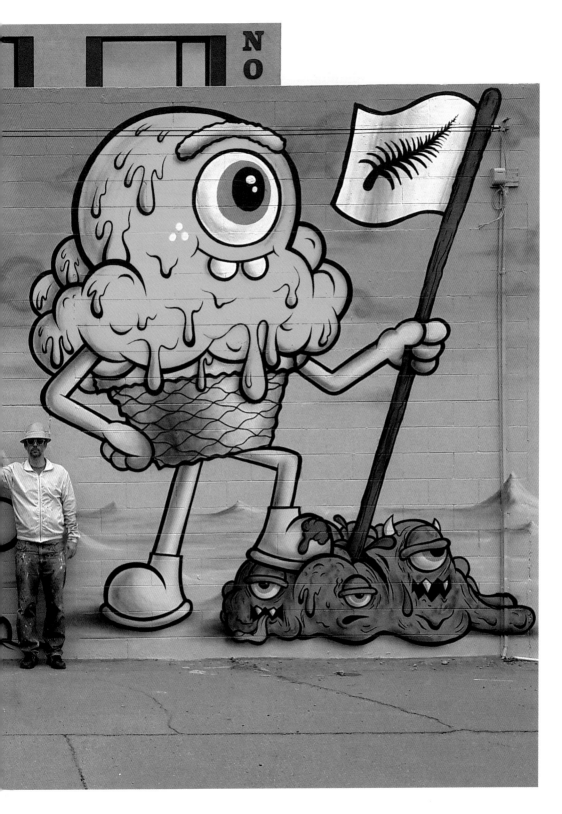

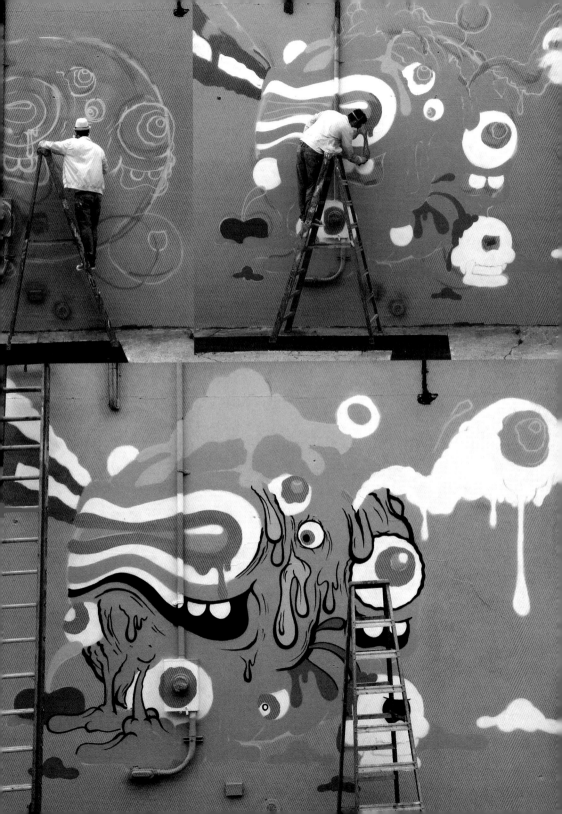

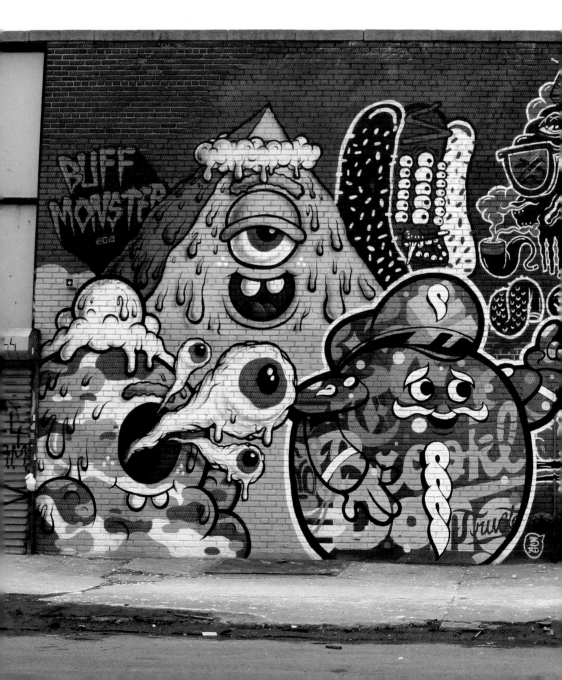

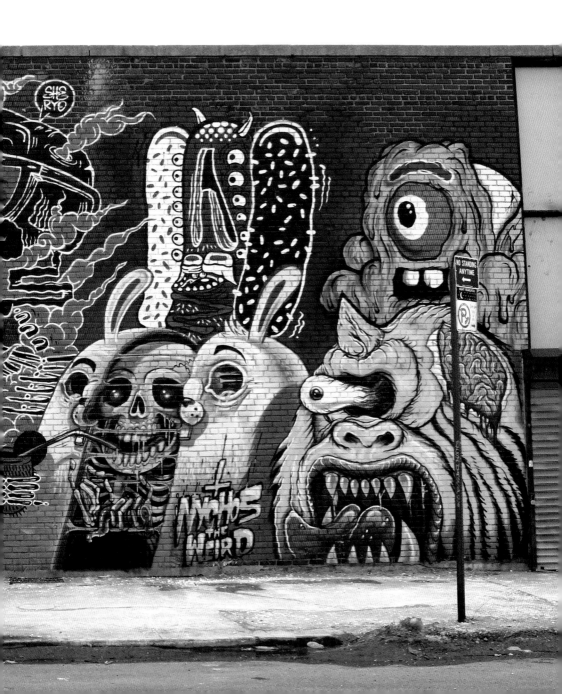

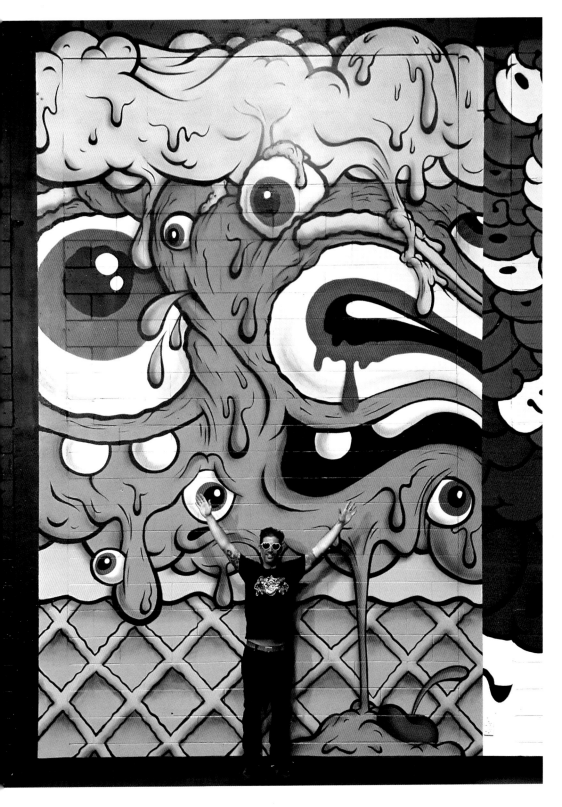

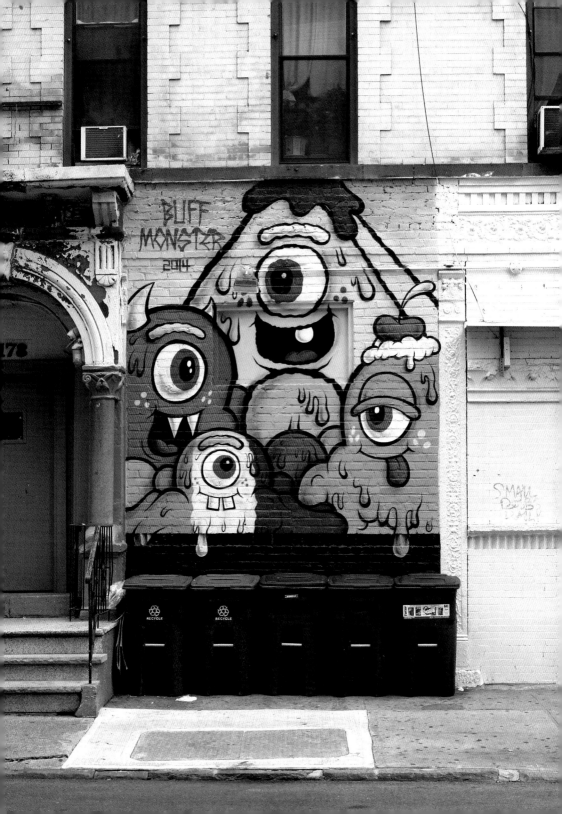

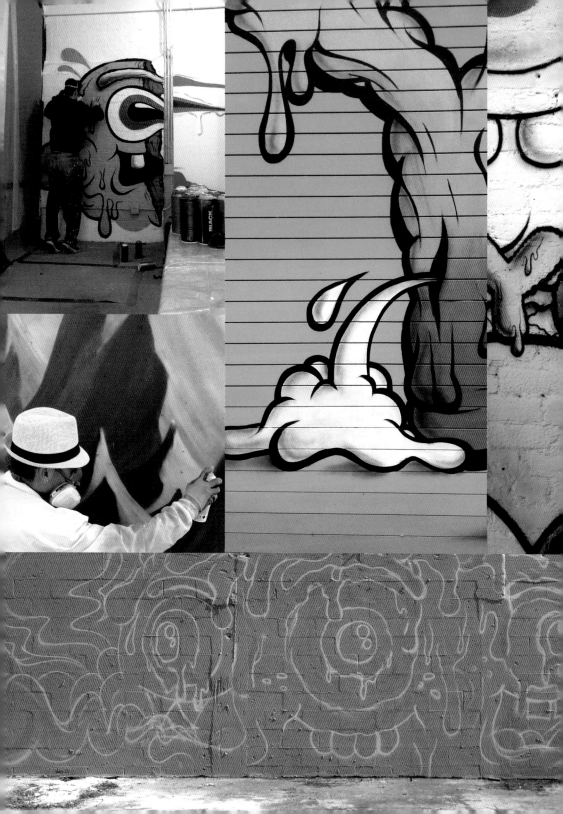

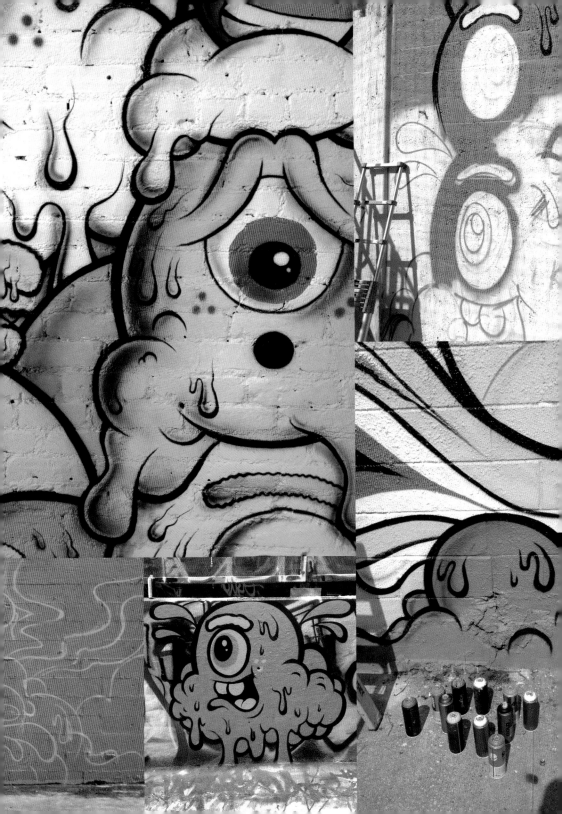

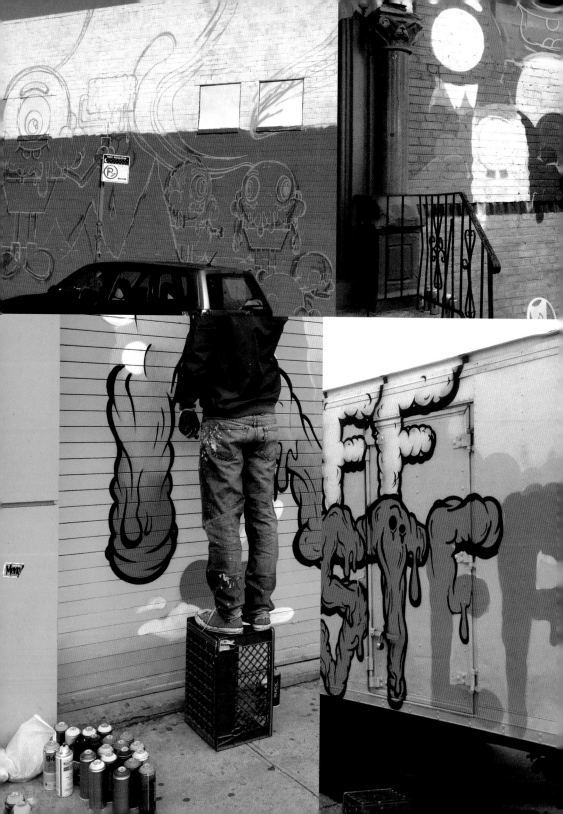

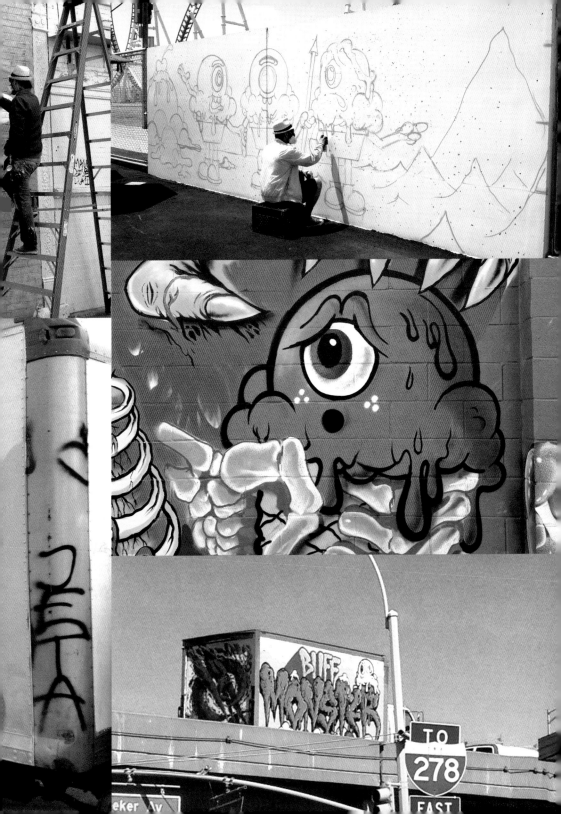

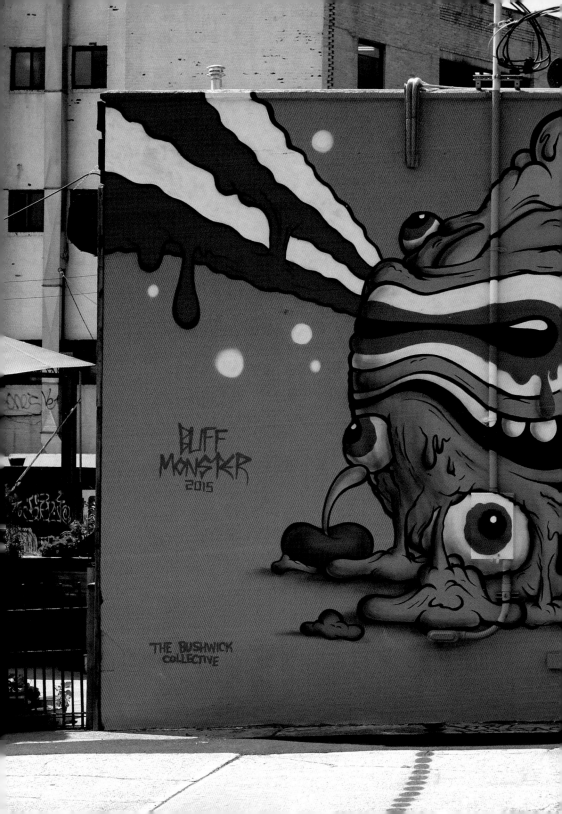

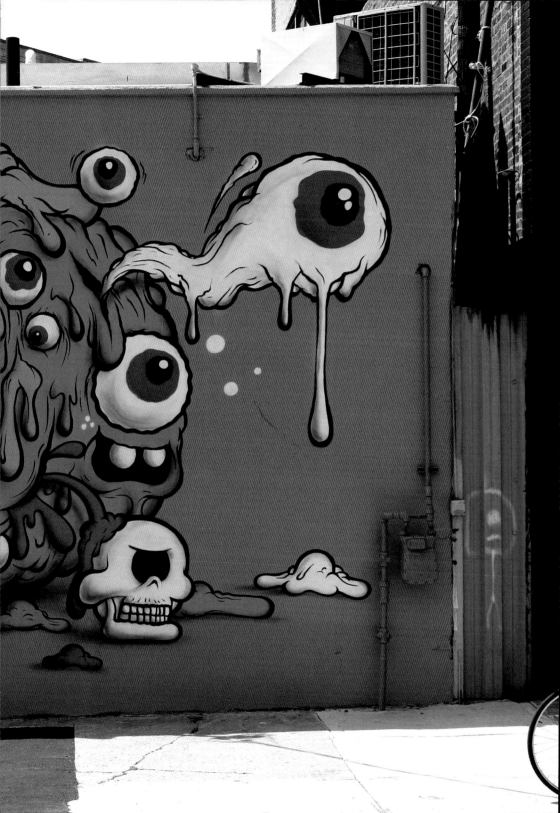

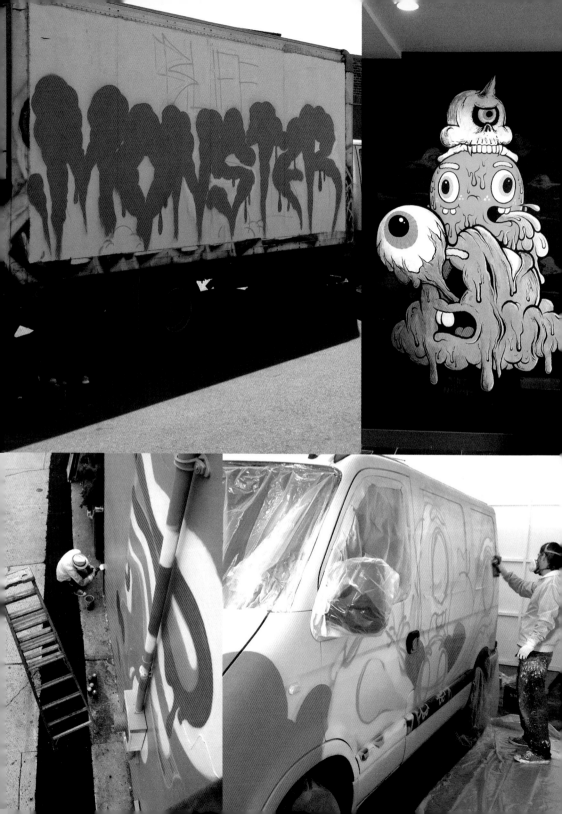

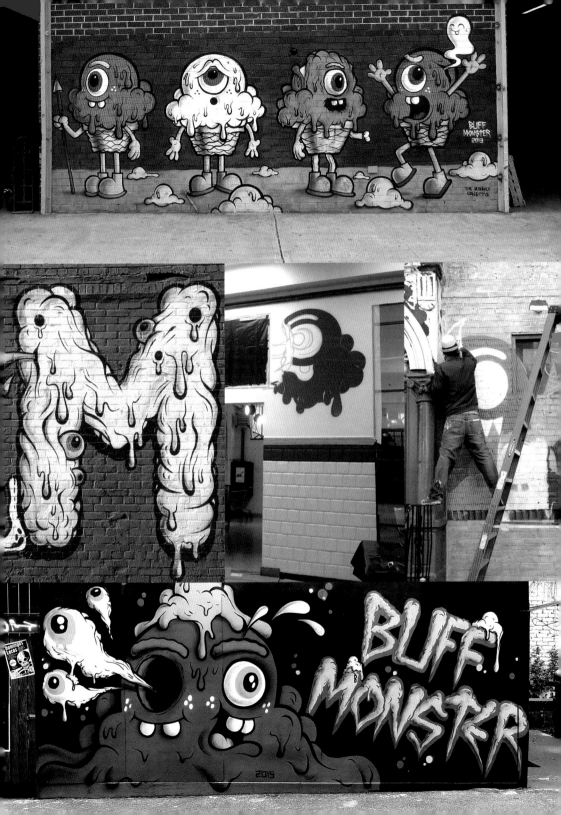

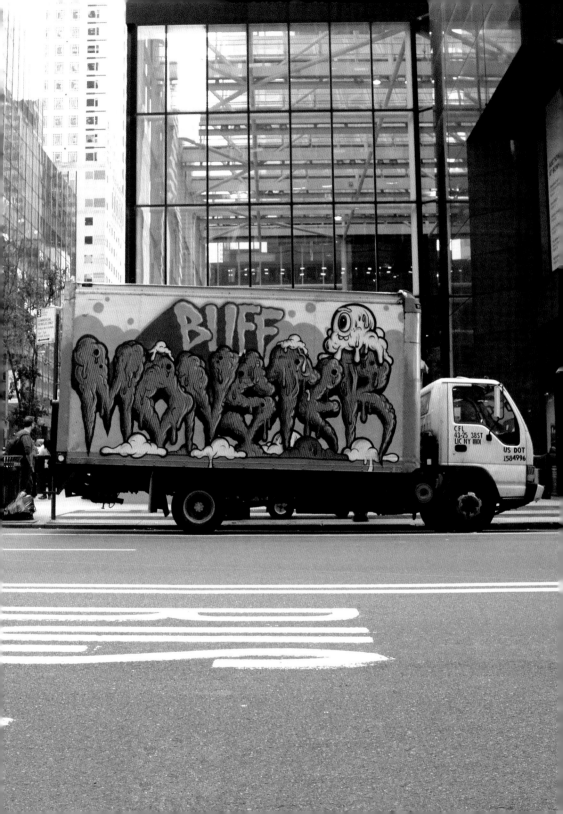

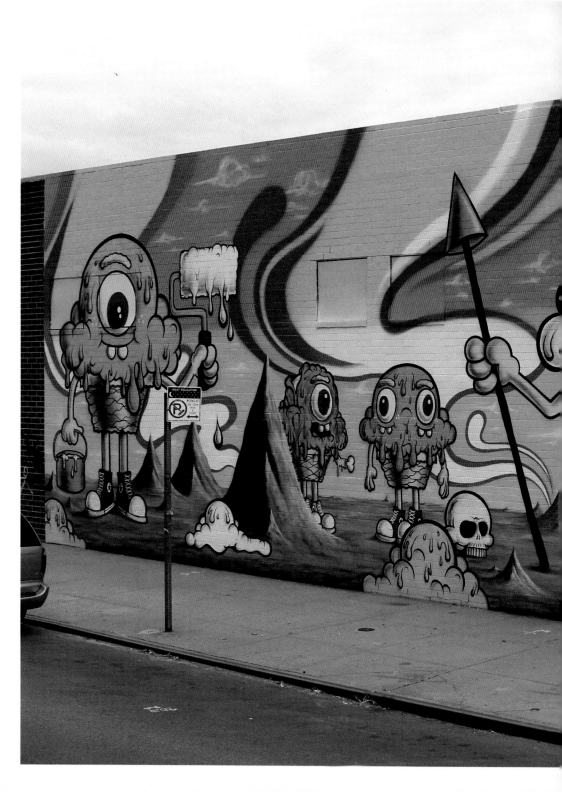

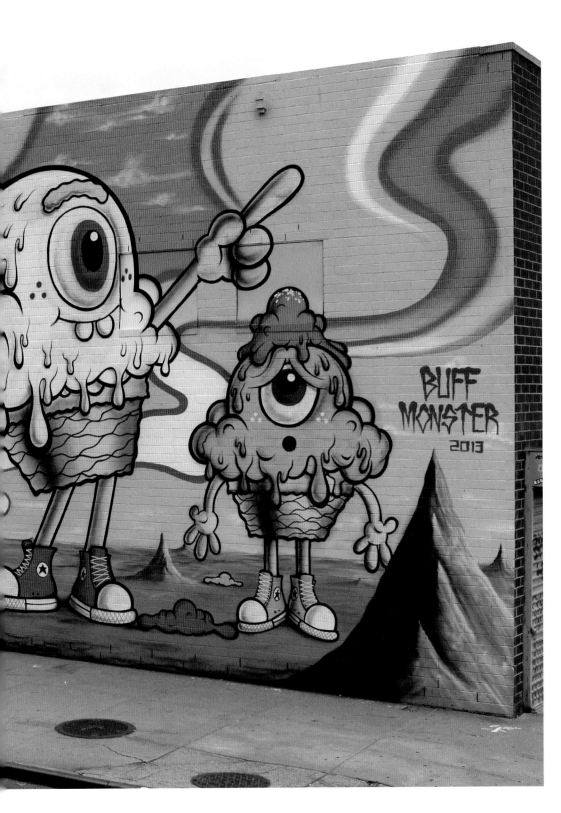

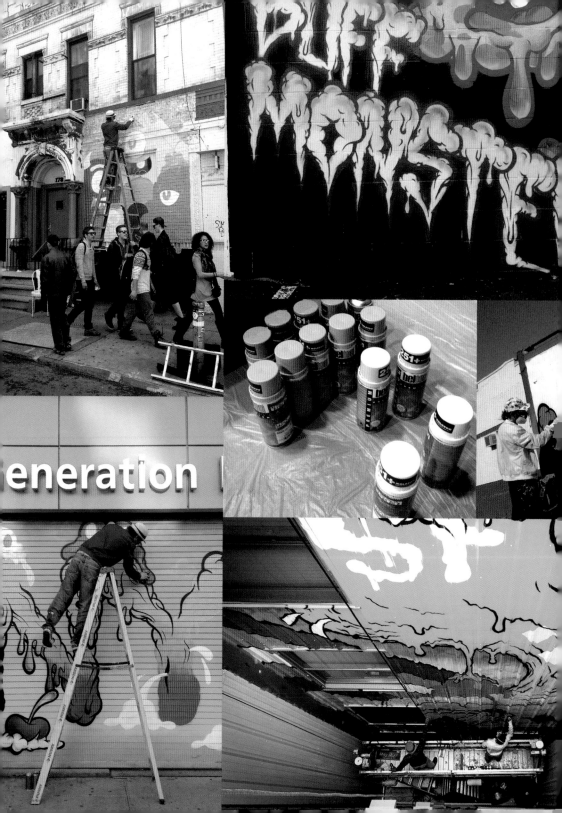

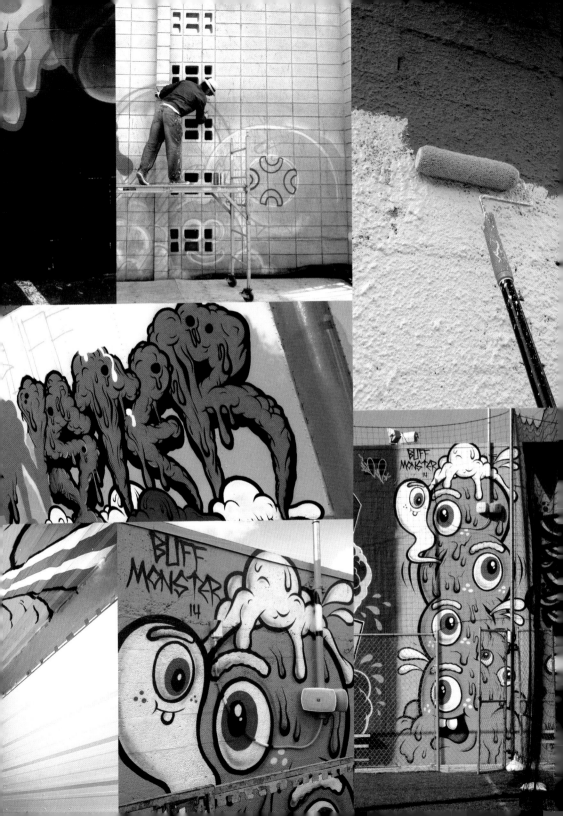

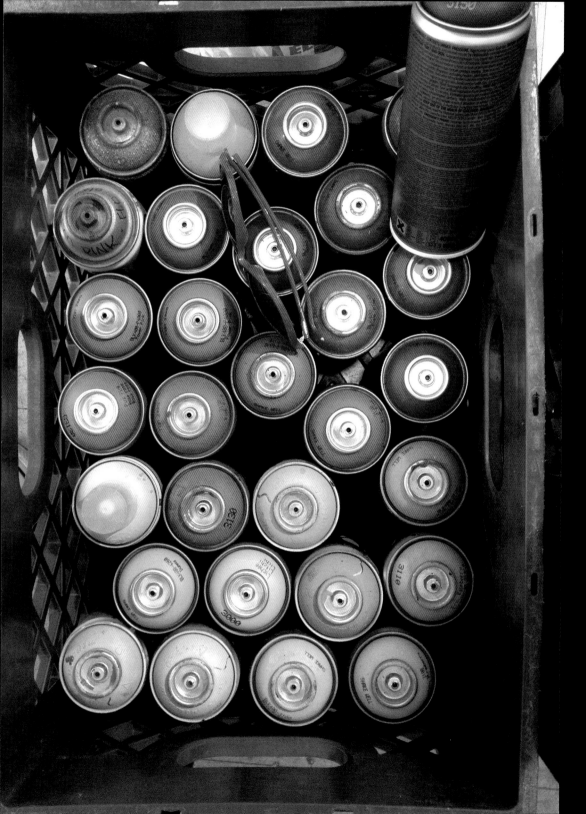

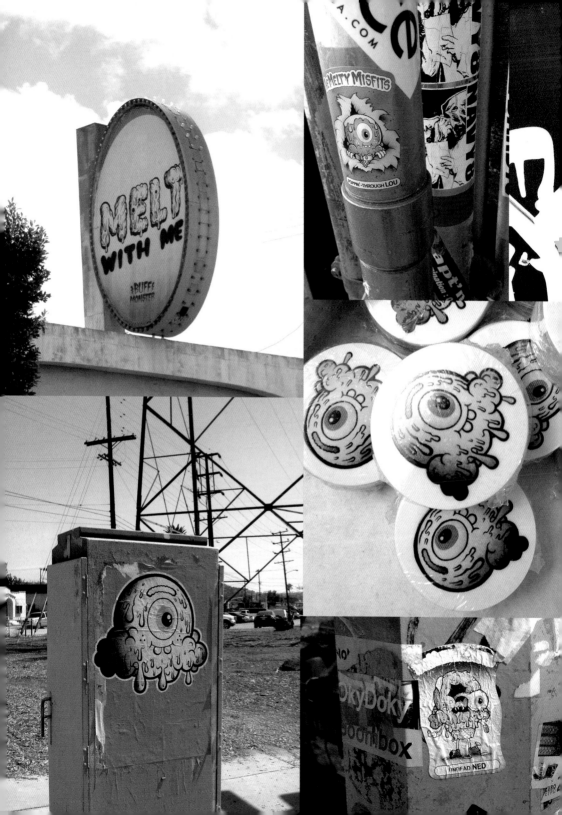

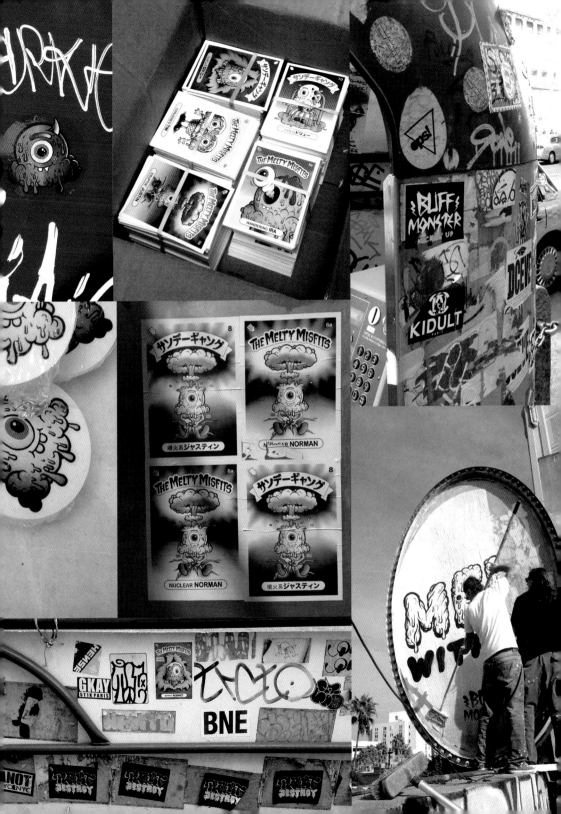

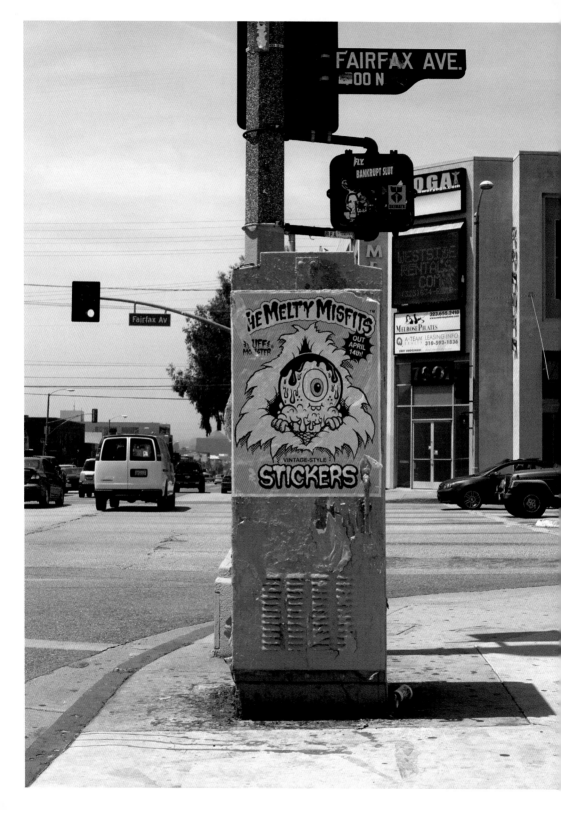

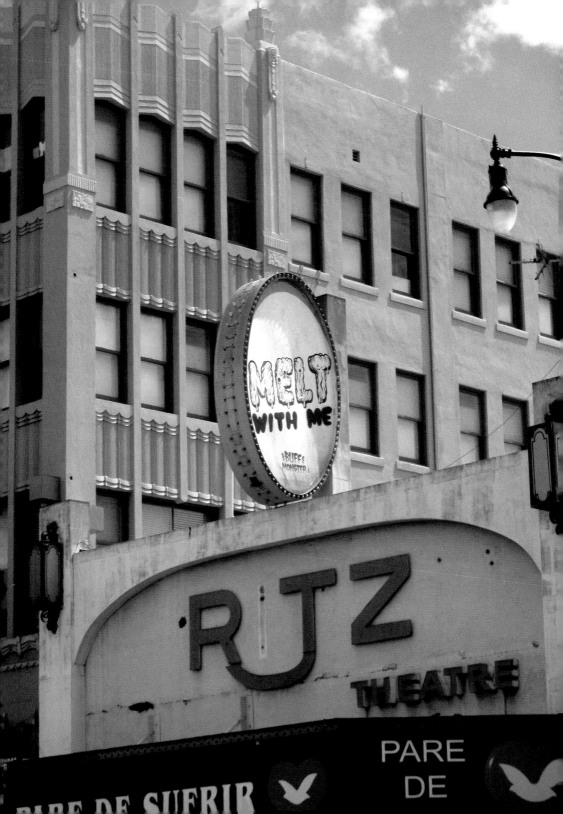

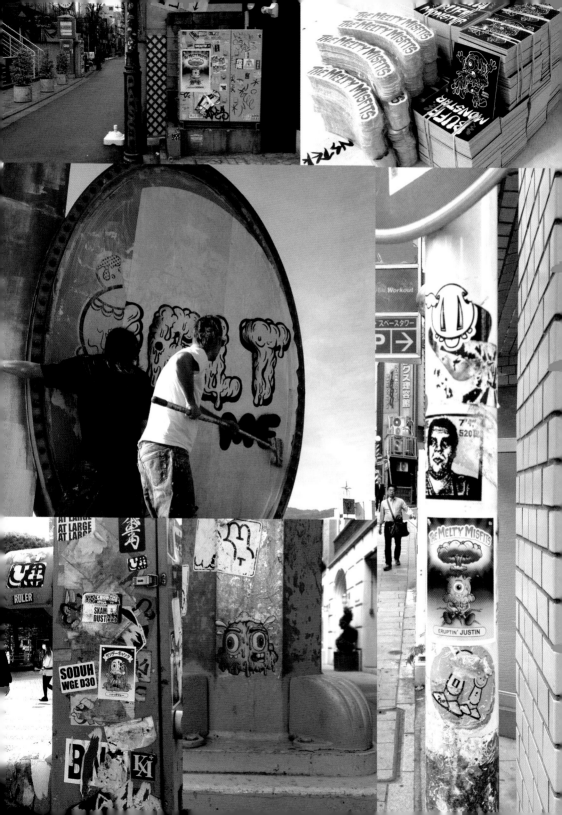

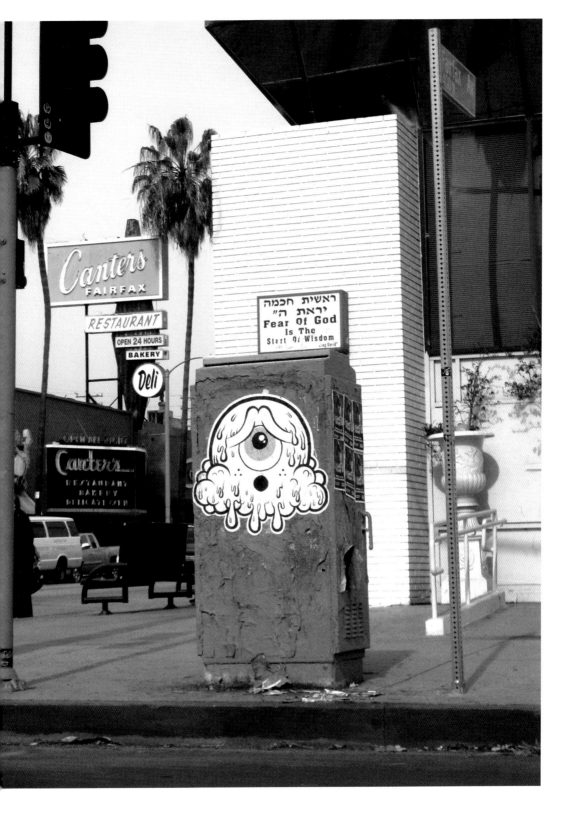

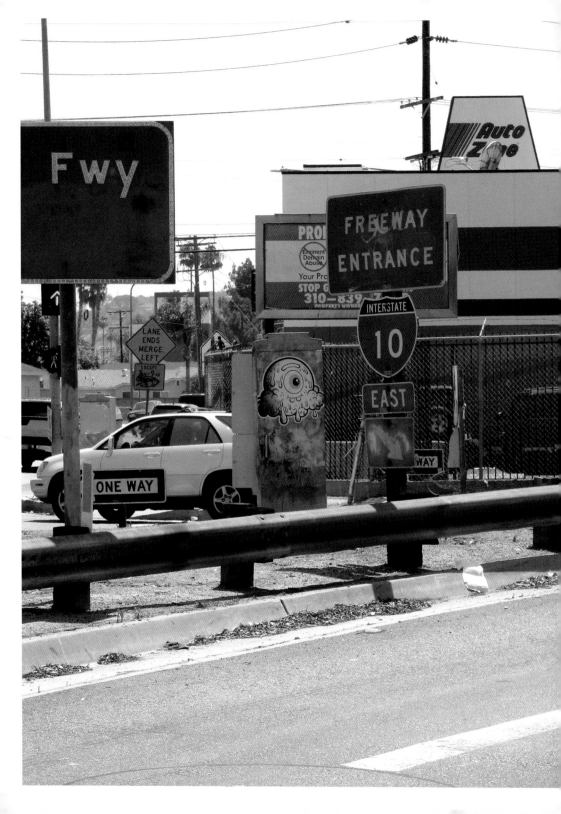

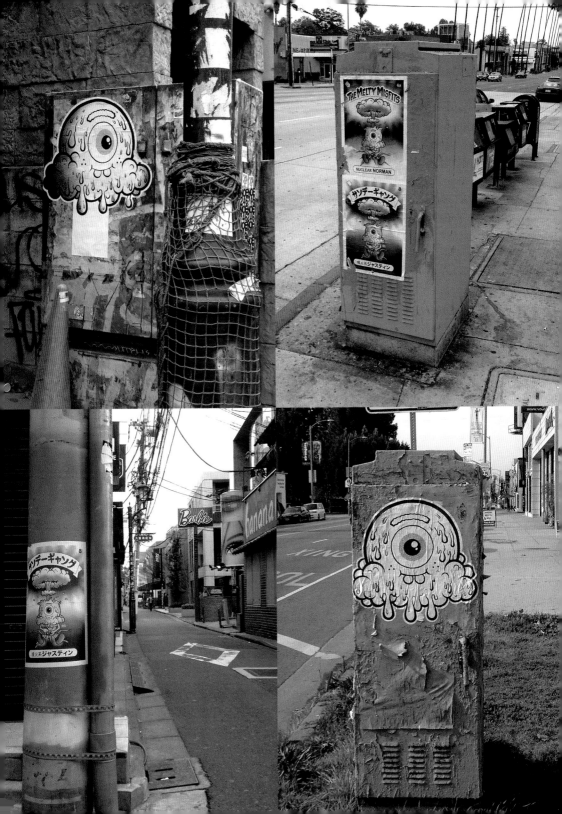

Right:
Original paintings for *The Melty Misfits Series 1*. Clockwise from top left:
Lethal Lenny / Deadly Donny
Fleshy Fletcher / Gooey Stewie
Siamese Sam / Conjoined Tim
Peter Preacher / Lucy Fer

I was seven years old when I first discovered *Garbage
Pail Kids* (trading cards). I have such fond memories
of collecting those cards as a kid and they surely left a
lasting impression on me. In 2012, with the expert help of
Tom (Sidekick Labs), I released the most ambitious hom-
age to *Garbage Pail Kids* ever: *The Melty Misfits*.

Each of the original 5x7" paintings used for the cards
was painted using acrylic and airbrush, just like the
original GPK paintings were done. The cards are offset
printed using custom-mixed inks on custom-made sticker
stock, kiss-cut and packaged in a vintage-style wax wrap-
per. The backs of the cards feature puzzles and check-
lists; the backs of the foil cards feature reproductions of
the pencil sketches used to paint the cards.

We've created a variety of special inserts such as er-
ror cards (intentionally misprinted in a variety of ways),
blank-back signed cards, original sketch cards, lenticular
(3D) cards, foil cards and variants. We've also created
VERY rare Golden Tickets, redeemable for an original
Melty Misfits painting.

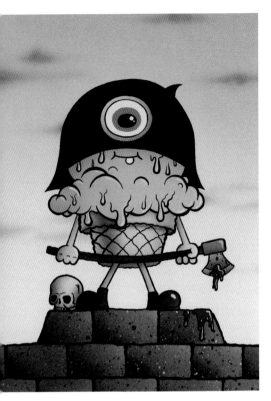
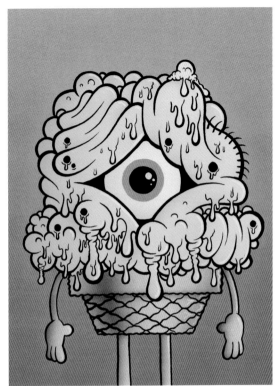
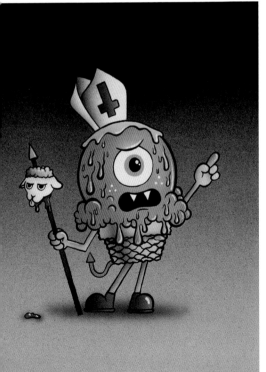
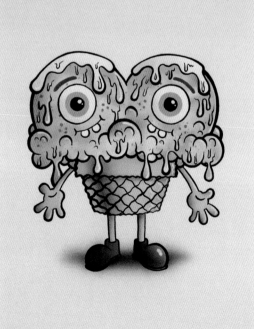

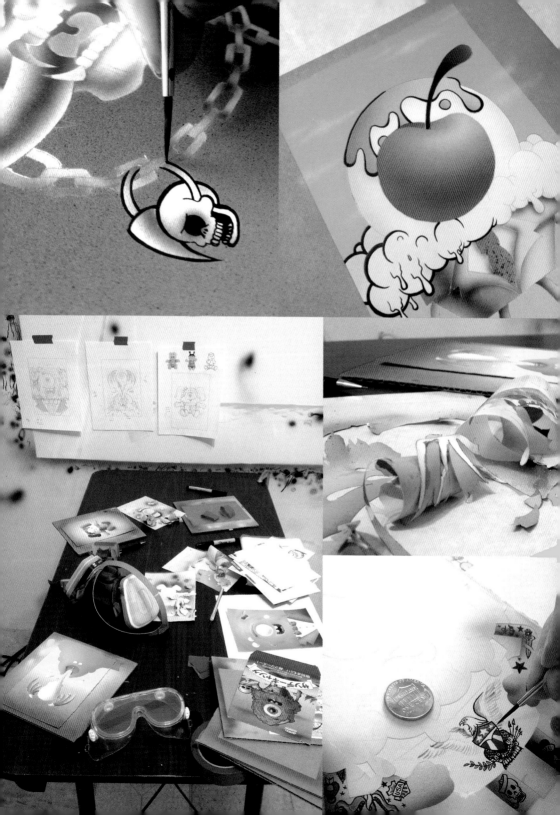

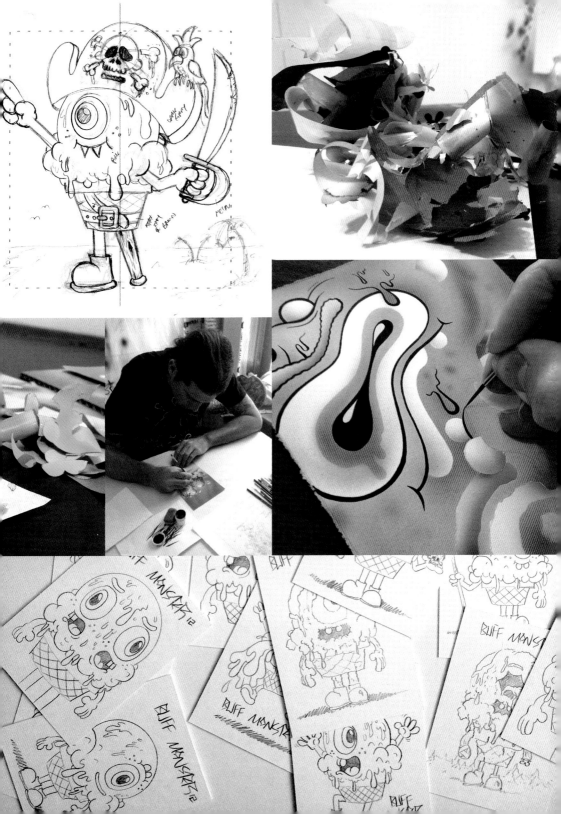

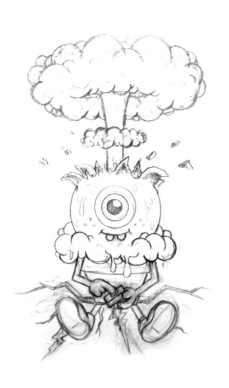

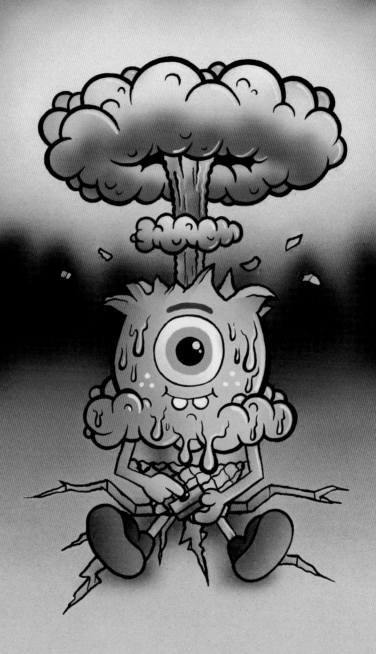

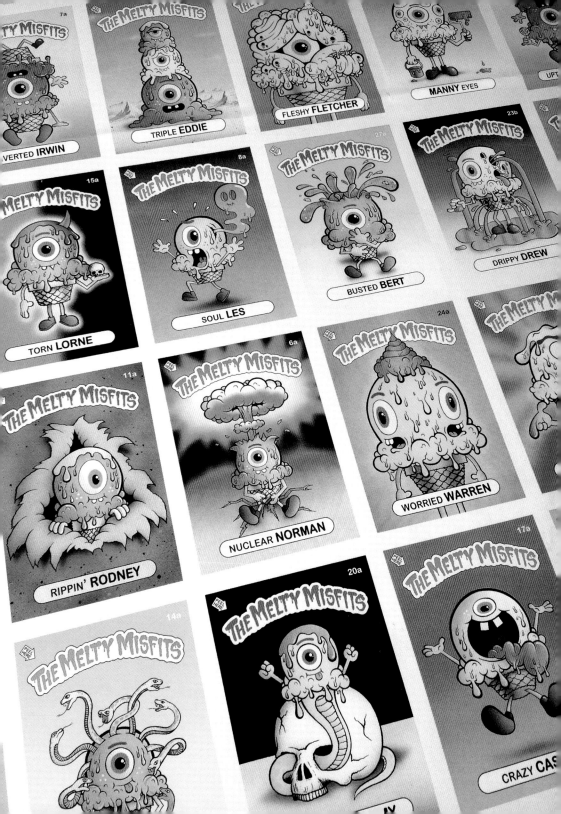

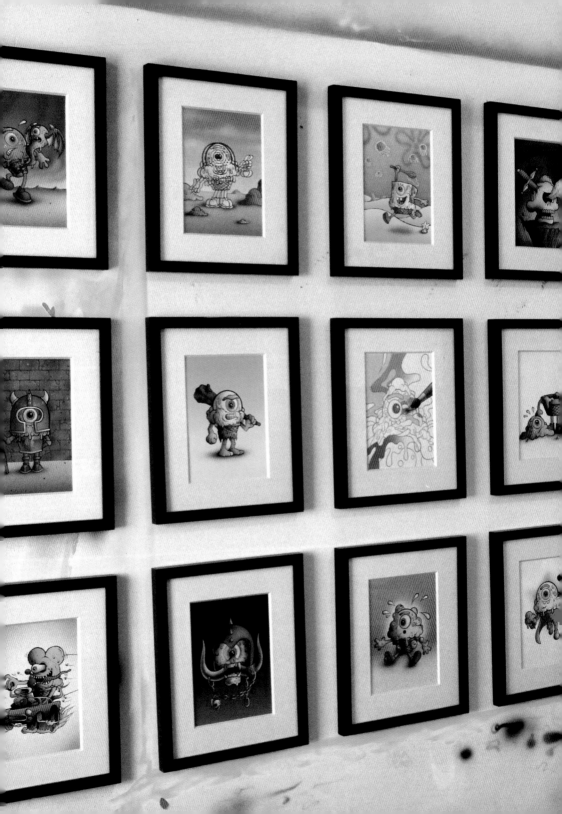

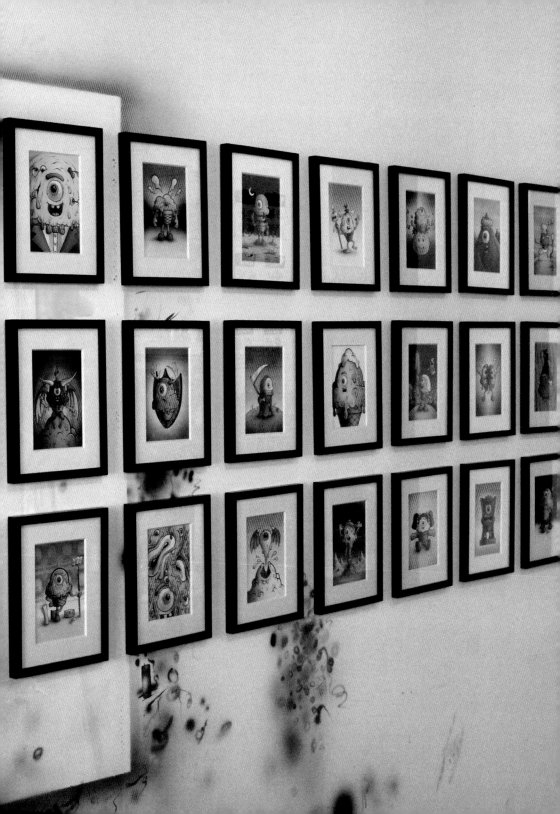

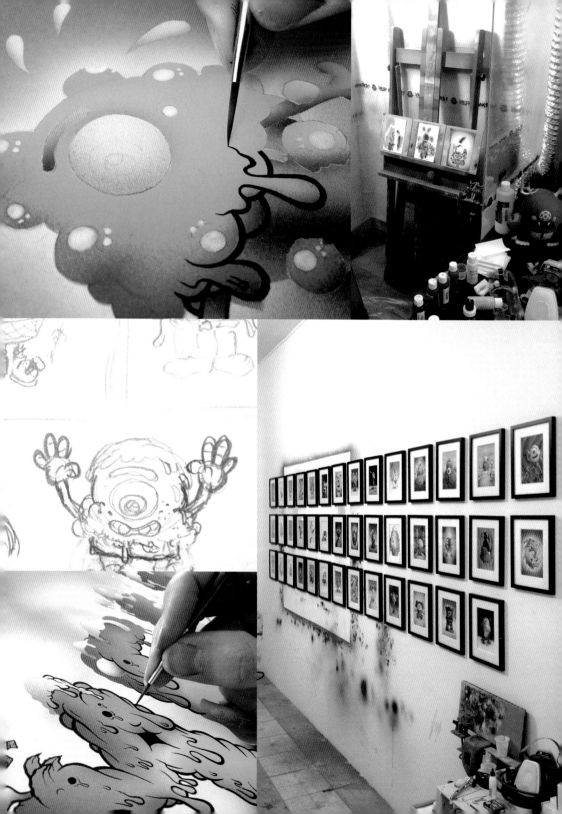

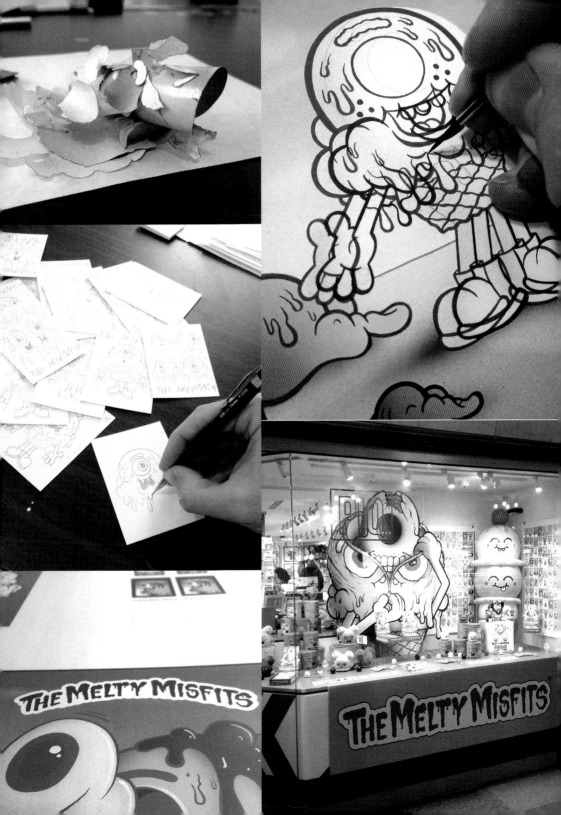

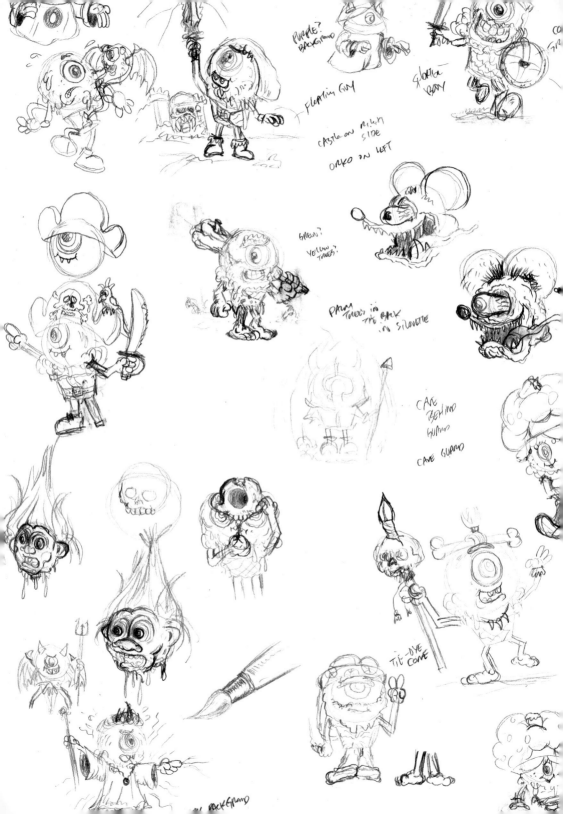

PURPLE?
BACKGROUND

FLOATING GUY

SHORTER
BODY

CASTLE ON RIGHT
SIDE

ORKO ON LEFT

GREEN?
YELLOW
TREES?

PALM
TREES in
THE BACK
in SILOUETTE

CAVE
BEHIND
GUARD

CAVE GUARD

TIE-DYE
CONE

BACKGROUND

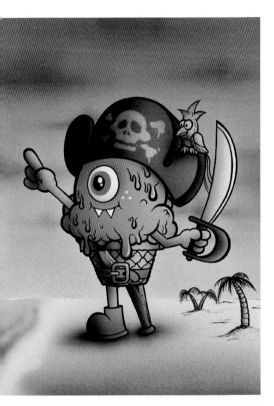
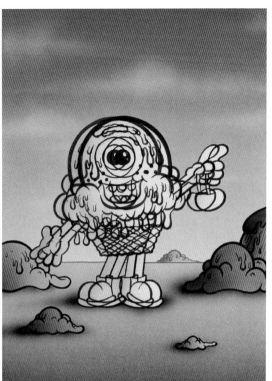
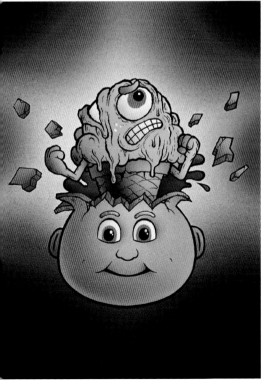
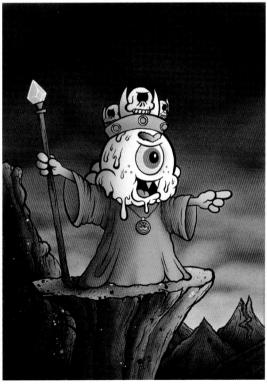

Previous Spread:

Left: Original pencil sketches for *The Melty Misfits Series 2*.
Right: Original paintings for *The Melty Misfits Series 2*. Clockwise from top left:
Katie Matey / Ahoy Roy
3D Petey / Off-Register Chester
Gandalf The Gooey / Hector Sceptor
Mind-Blowin' Owen / Burstin' Thurston

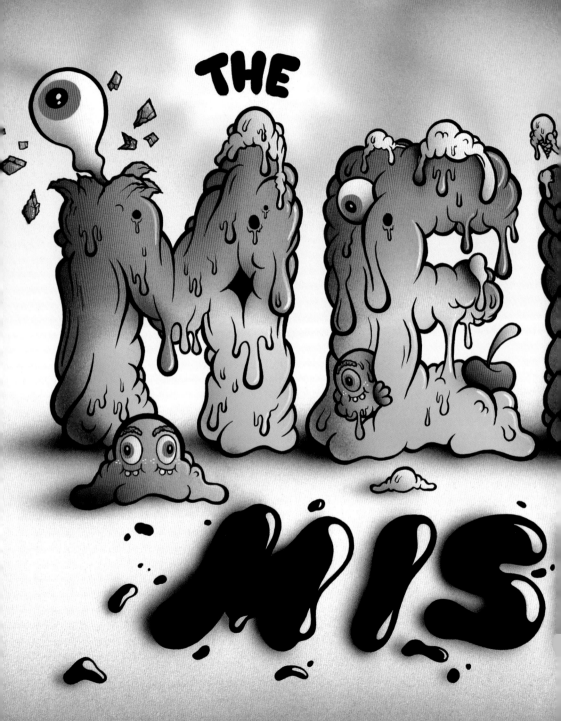

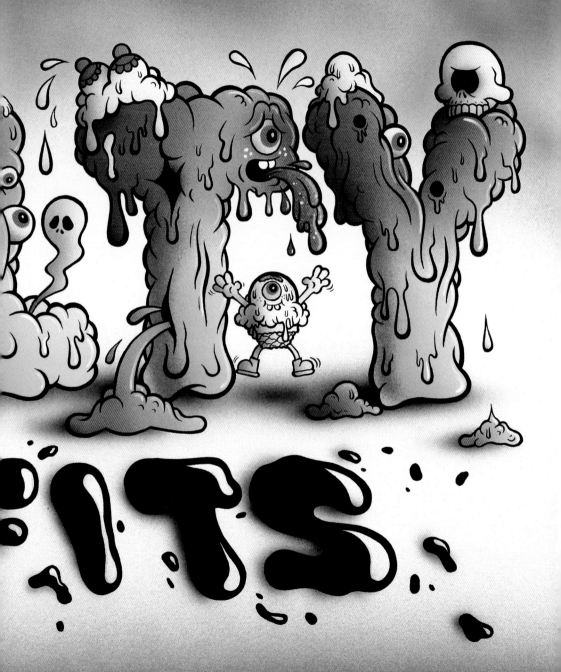

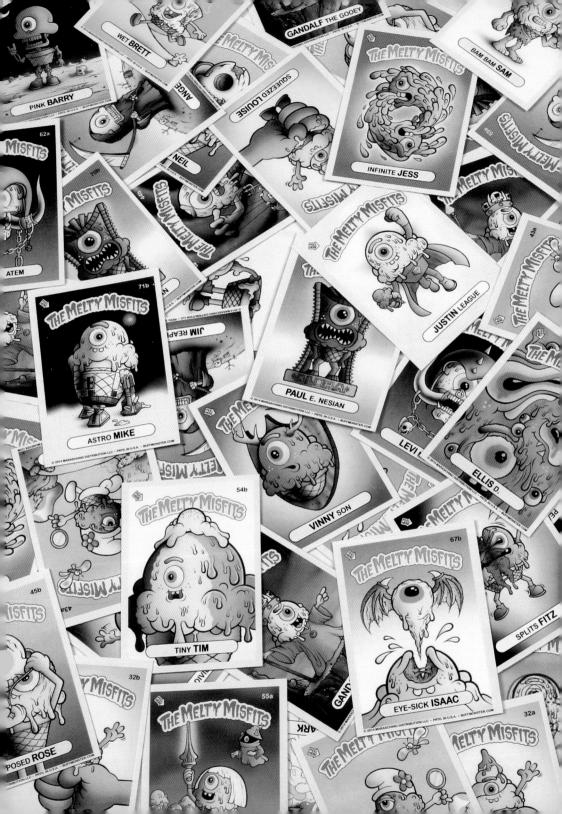

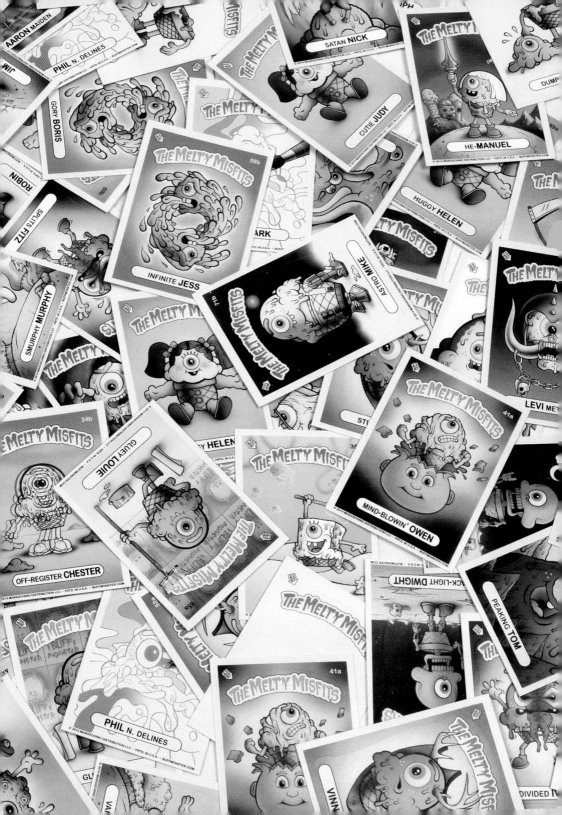

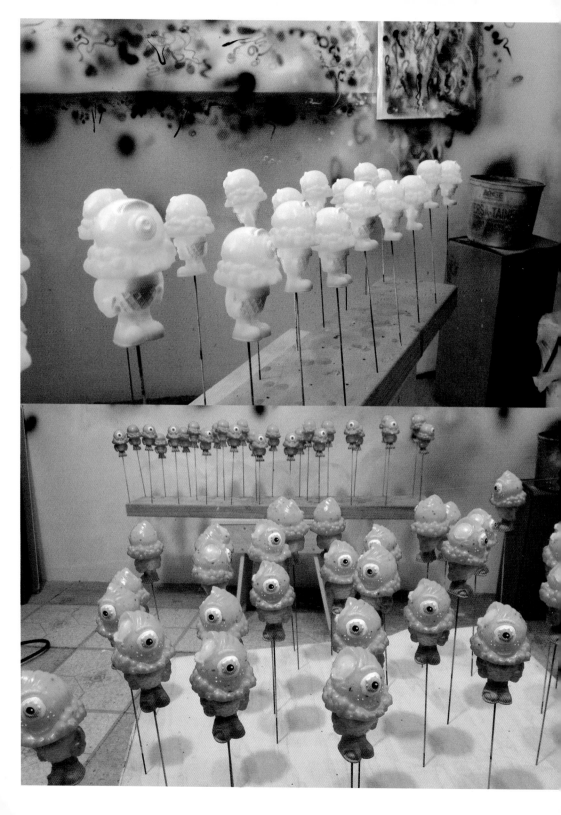

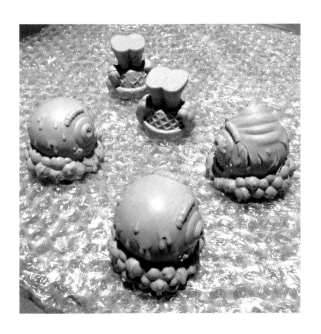

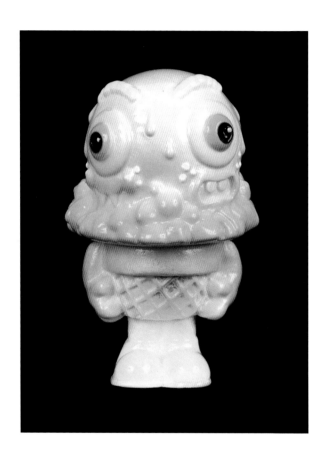

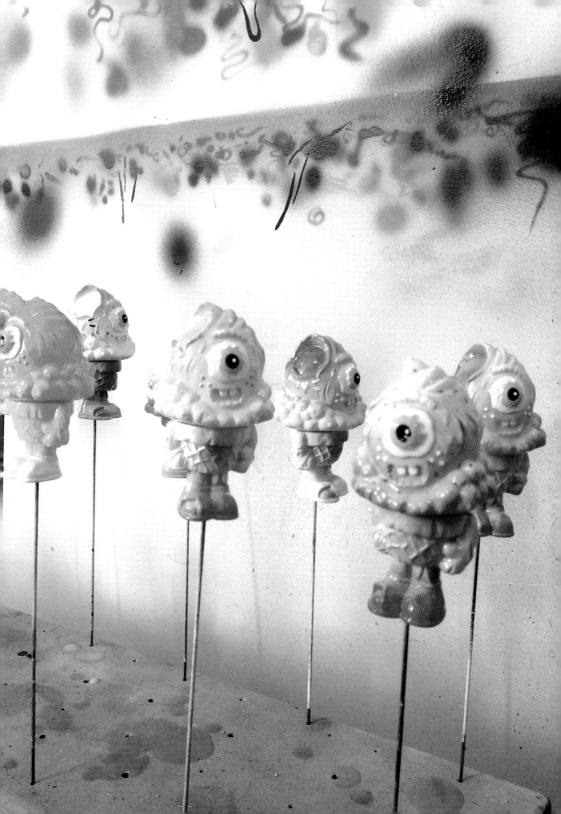

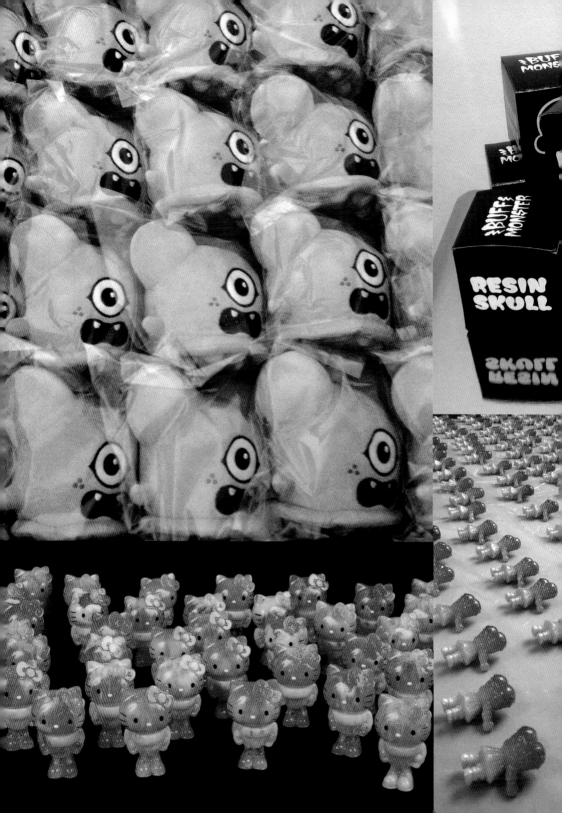

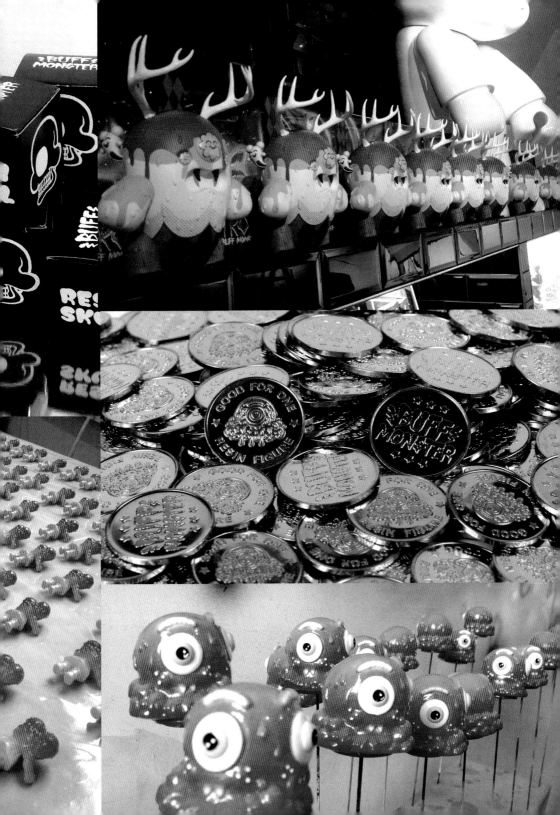

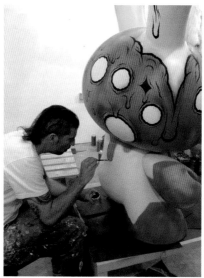

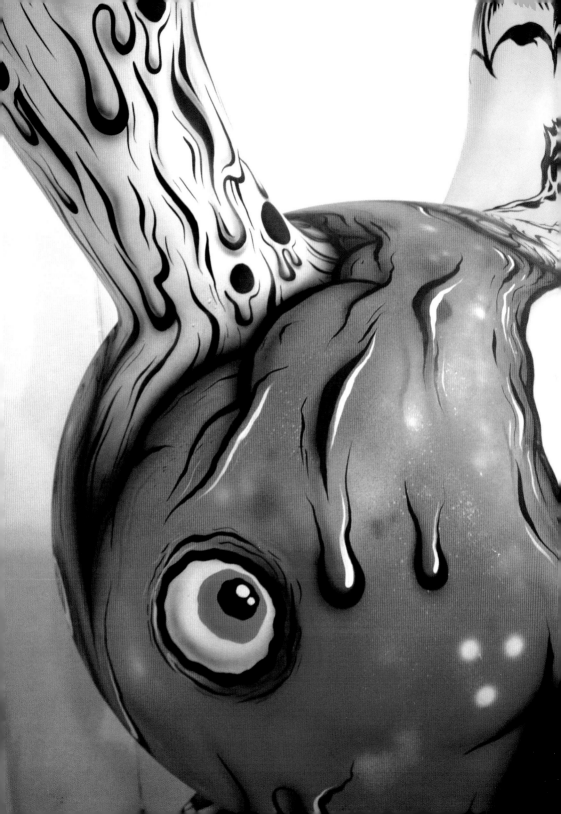

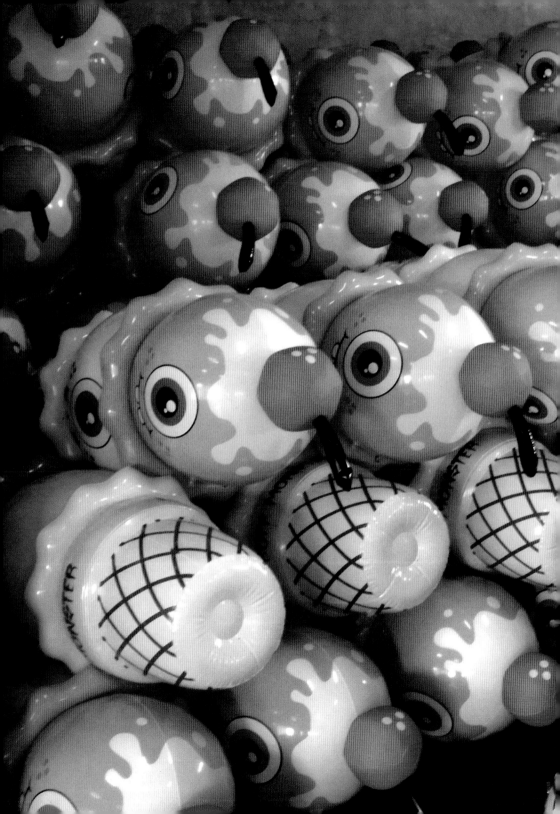

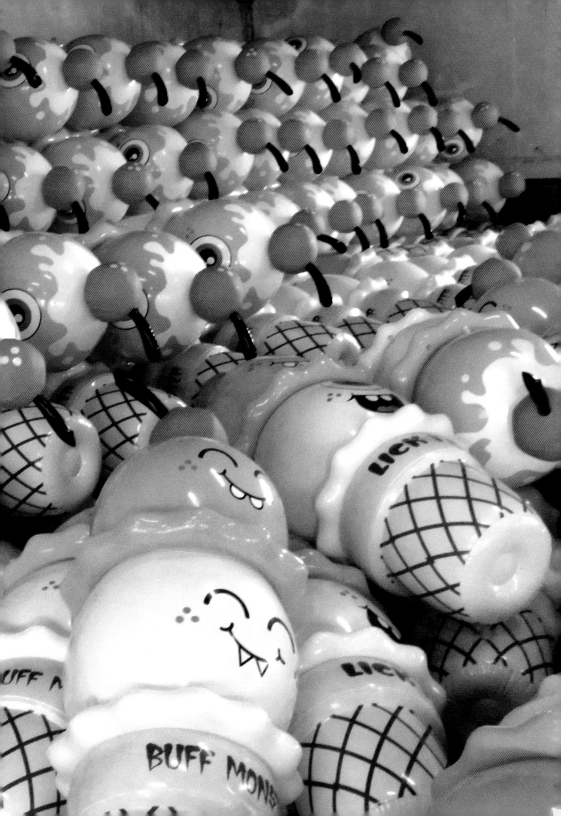

1: One of eight huge spray cans produced for the Spectrum Street Art Festival in Christchurch, New Zealand, 2015. Designed by Eddie Zammit of T-World.

2: Hand-painted oversized drippy cell phone sculpture. Produced by Pretty in Plastic, 2013.

3: Hand-painted delivery van for Toykio in Dusseldorf, Germany, 2013.

1

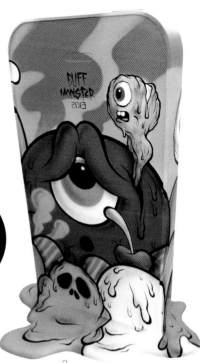

2

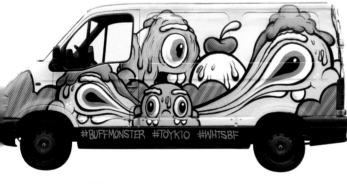

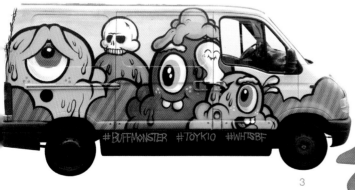

3

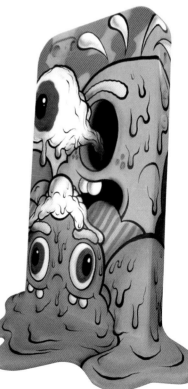

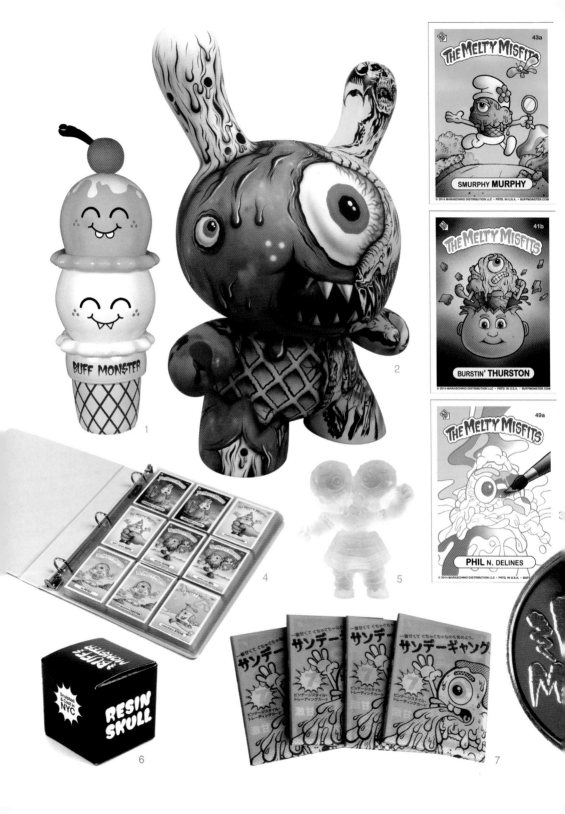

THE MELTY MISFITS 43a
SMURPHY MURPHY
© 2014 MARASCHINO DISTRIBUTION LLC · PRTD. IN U.S.A. · BUFFMONSTER.COM

THE MELTY MISFITS 41b
BURSTIN' THURSTON
© 2014 MARASCHINO DISTRIBUTION LLC · PRTD. IN U.S.A. · BUFFMONSTER.COM

THE MELTY MISFITS 49a
PHIL N. DELINES
© 2014 MARASCHINO DISTRIBUTION LLC · PRTD. IN U.S.A. · BUFF

BUFF MONSTER

1

2

4

5

RESIN SKULL

BUFF MONSTER

Sculpted & Cast in NYC

6

サンデー

サンデー

サンデー

サンデーギャング

一番甘くて ぐちゃぐちゃなのを集めよう。

7

ビンテージスタイル・トレーディングカード

激甘

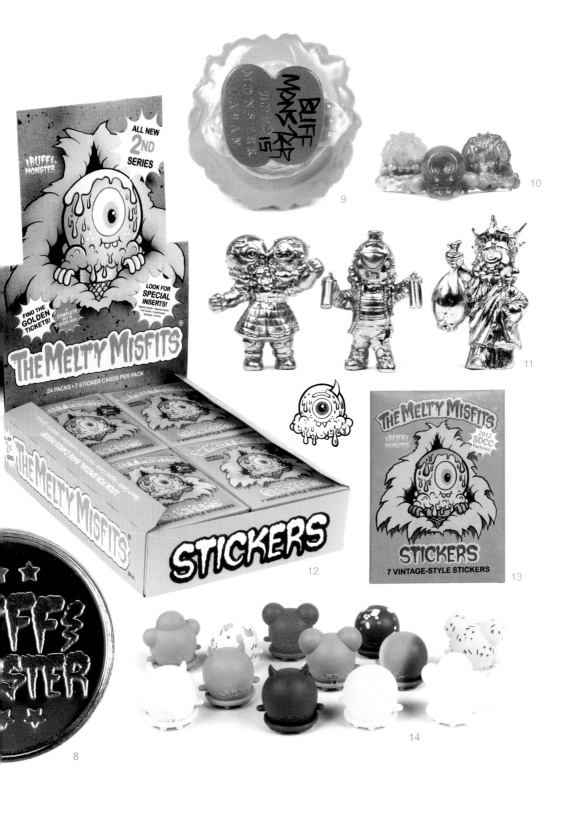

ALL NEW 2ND SERIES

BUFF MONSTER

FIND THE GOLDEN TICKETS!

LOOK FOR SPECIAL INSERTS!

THE MELTY MISFITS

24 PACKS • 7 STICKER CARDS PER PACK

STICKERS

BUFF MONSTER JAPAN 2015

9

10

11

THE MELTY MISFITS

BUFF MONSTER

2012 SDCC Exclusive

STICKERS

7 VINTAGE-STYLE STICKERS

12

13

8

14

Previous Spread:

1: *Ice Cream Inflatable* (side 2), 52" tall, 2015.
2: Hand-painted *Giant Dunny* (collaboration with L'Amour Supreme). 48" tall, 2013.
3: A few cards from *The Melty Misfits Series 2*, 2014.
4: *The Melty Misfits Series 2* sticker album, 2014.
5: Clear *Double Heather* figure, 1.5" tall, 2013.
6: *Resin Skull* (packaging), 2x2x2", 2014.
7: Four packs of the *Japanese Melty Misfits* trading cards, 2012.
8: Token for the *Toy Machine*, 2013.
9: Hand-painted *Mister Melty* vinyl toy, 3" tall, 2015.
10: A few *Ice Cream Resin Heads* from the *Toy Machine*, 1" tall, 2013.
11: Set of bronze *Melty Misfits* toys (*Double Heather, Graffiti Petey, Alice Island*), 1.35" tall, 2014.
12: Complete box of *The Melty Misfits Series 2* trading cards/stickers, 2014.
13: San Diego Comic Con Exclusive pack of *The Melty Misfits* (Series 1), 2012.
14: Complete set of *Ice Cream Minis*, produced in 2006, packaged as a set in 2014.

Ice Cream Inflatable (in Buff Monster's studio), 52" tall, 2015.

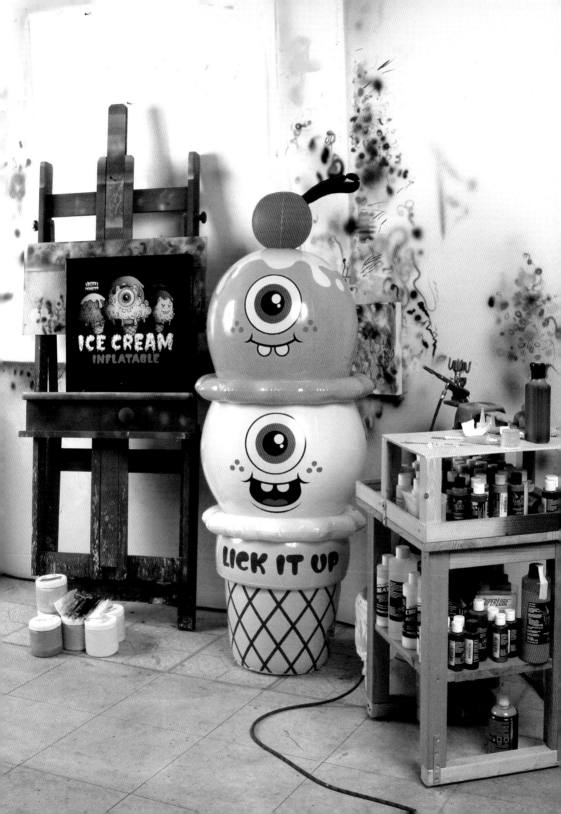

1: Two hand-painted *Munny*s, 18" tall, 2014. Painted live at the Holypop store in Rome, Italy.
2: *Melty Kitty* resin figure, 3" tall, 2014. Produced on the occasion of the 40th Anniversary of *Hello Kitty*.
3: *Resin Skull* with packaging, 1.5" tall, 2014.
4. Unopened box of *The Melty Misfits Series 2* trading cards/stickers, 2014.
5: Complete set of the original *Melty Misfits Cheap Toys* (*Double Heather*), 1.5" tall, 2013.
6: *Ralphin' Ralph* t-shirt, 2012.
7: Complete box of *The Melty Misfits Series 1* trading cards/stickers, 2012.
8: T-shirt design for Mishka (collaboration with L'Amour Supreme), 2013.
9: Pink *Mister Melty* (*Zombie variation*) vinyl toy, 3" tall, 2014.

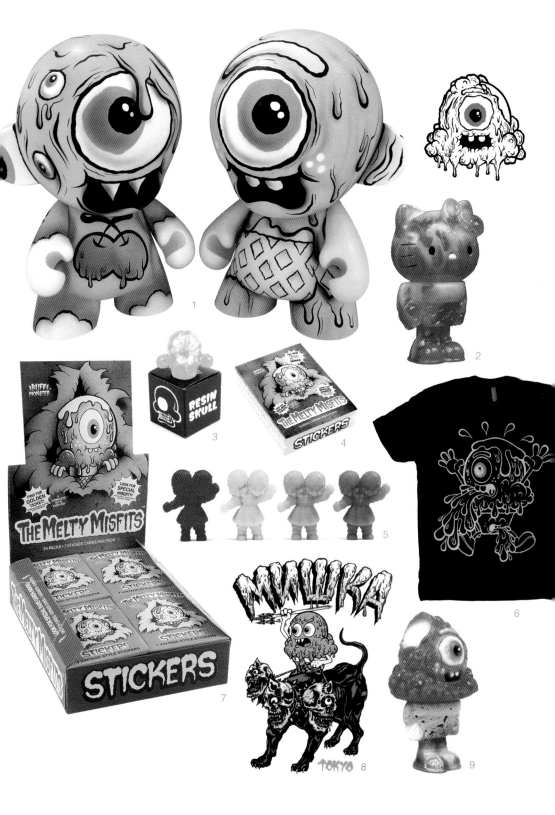

1

2

3

RESIN
SKULL

THE MELTY MISFITS
STICKERS

4

5

6

BUFF
MONSTER

FIND THE
GOLDEN
TICKET!

LOOK FOR
SPECIAL
INSERTS!

THE MELTY MISFITS
24 PACKS • 7 STICKER CARDS PER PACK

MELTY MISFITS
STICKERS
STYLE STICKERS

MELTY MISFITS
STICKERS
STYLE STICKERS

MELTY MISFITS
STICKERS
STYLE STICKERS

MELTY MISFITS
STICKERS
STYLE STICKERS

STICKERS

7

MUWKA

TOKYO 8

9

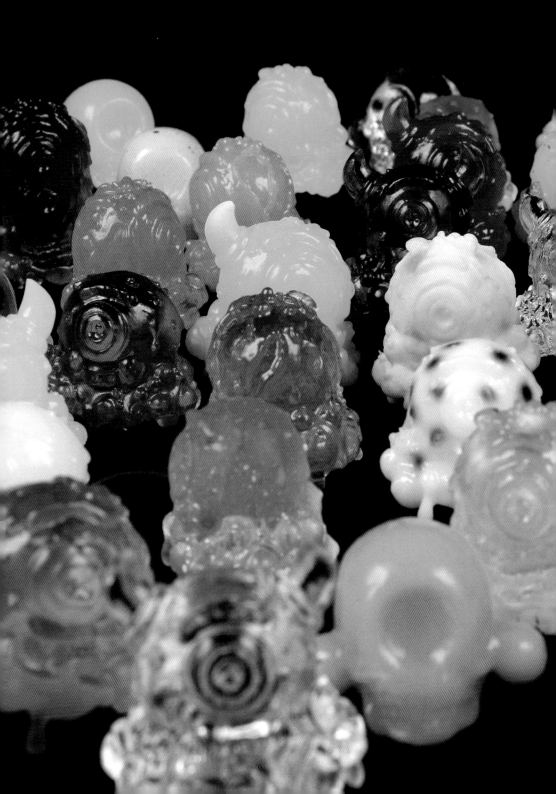

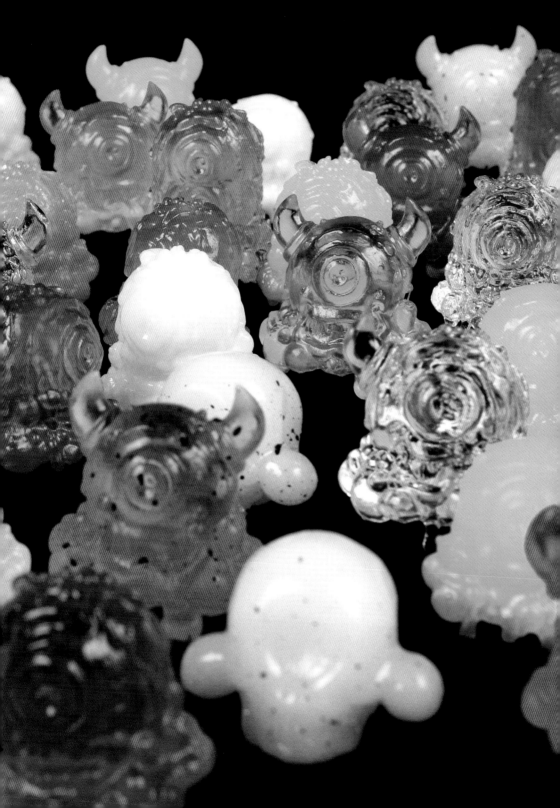

Previous Spread:

Various *Ice Cream Resin Heads* (cast by hand, some hand-painted) from the *Toy Machine*, 1" tall, 2013.

1: *The Melty Misifts Series 2* sticker album, 2014.
2: Set of two Kickstarter-exclusive *Mister Melty* vinyl toys, 3" tall, 2014.
3: T-shirt design for Kidrobot, 2013.
4: A variety of misprinted ("error") cards from *The Melty Misfits Series 2*, 2014.
5: Hand-painted Giant *Dunny* (collaboration with L'Amour Supreme). 48" tall, 2013.
6: San Diego Comic Con Exclusive card (front and back) from *The Melty Misfists Series 1*, 2012.
7: *The Melty Misfits* t-shirt, 2012.
8: Green *Melty Misfits Cheap Toy* (*Double Heather*) in packaging, 1.5" tall, 2013.

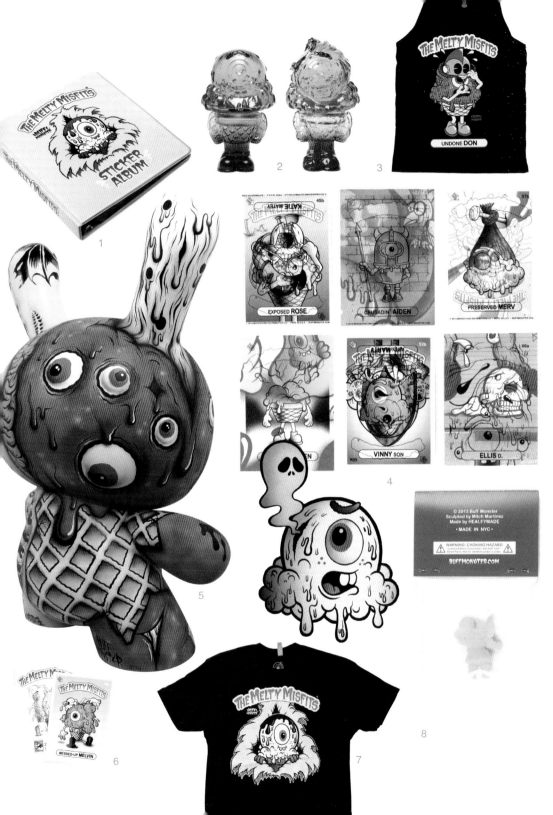

1

2

3 UNDONE DON

4
EXPOSED ROSE 45b
CRUSADIN' AIDEN
PRESERVED MERV 57b
52b VINNY SON
66a ELLIS D.

© 2013 Buff Monster
Sculpted by Mitch Martinez
Made by HEALEYMADE
• MADE IN NYC •

WARNING: CHOKING HAZARD
BUFFMONSTER.COM

5

6 MESSED-UP MELVIN

7

8

Complete sets of *The Melty Misfits Series 2* trading cards/stickers (Kickstarter-exclusive).

1: The *Toy Machine*: a vintage-style vending machine filled with hand-cast resin figures (see #4 below), 2013.
2: Green *Mister Melty* in packaging (front and back) vinyl toy, 3", 2014.
3: Pink *Mister Melty* (*Two-Faced*) vinyl head, 1.5" tall, 2014.
4: *Ice Cream Resin Head* (from the *Toy Machine*). Hand-cast in a variety of colors (some hand-painted) packaged in a plastic capsule, with a mini Certificate of Authenticity. 1" tall, 2013.
5: Bronze *Graffiti Petey*, 1.5" tall, 2014.
6: Four cards from *The Melty Misfits Series 1*, 2012.
7: A stack of foil cards from *The Melty Misfits Series 2*, 2014.

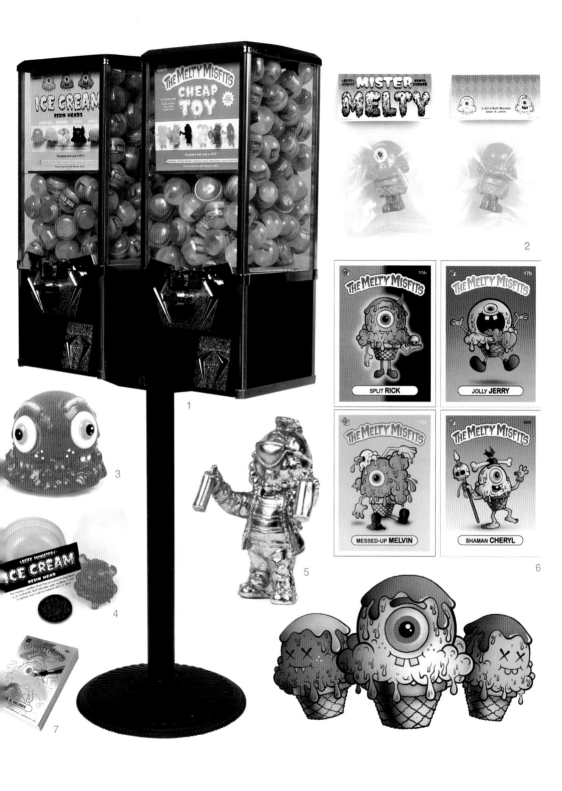

ICE CREAM
RESIN HEADS

THE MELTY MISFITS
CHEAP TOY

MISTER MELTY

1

2

3

4

5

6

7

SPLIT RICK

JOLLY JERRY

MESSED-UP MELVIN

SHAMAN CHERYL

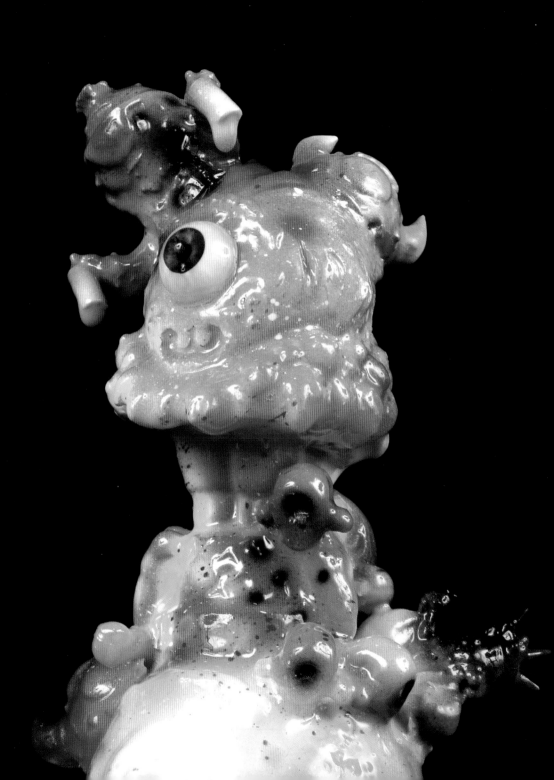

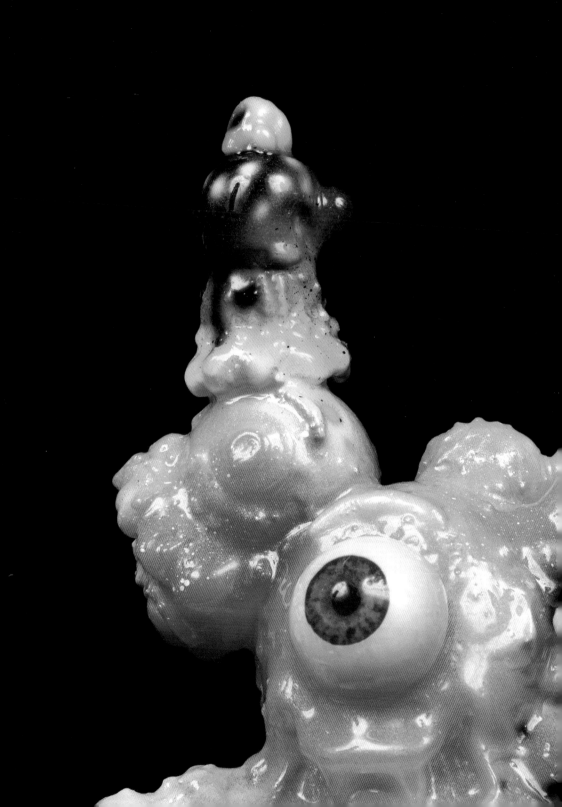

Previous Spread:

Two unique *Untitled* hand-painted resin sculptures, approximately 7" tall, 2014.

Eye Heart NY, 2015.
Silkscreen print on cotton rag paper, 24x24"
Signed and numbered edition of 100.

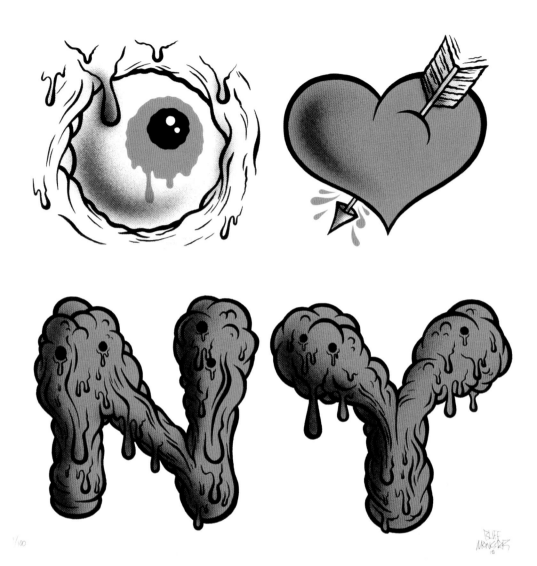

1/100

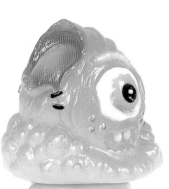

1

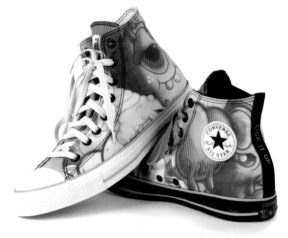

2

3

4

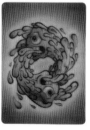

5

6

7

8

9

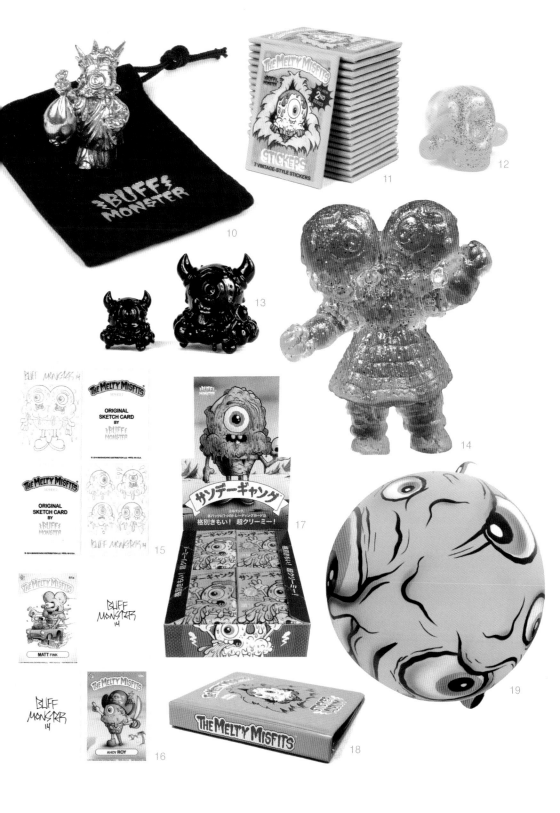

10

11

12

13

14

15

16

17

18

19

Previous Spread:

1: Hand-painted *Mister Melty* (*Zombie variation*) vinyl toy, 3" tall, 2015.
2: Official *Buff Monster Chuck Taylor All-Stars* by Converse, 2014.
3: Clear *Mister Melty (Two-Faced)* vinyl head, 1.5" tall, 2014.
4: Lenticular card (front and back) from *The Melty Misfits Series 2*, 2014.
5: Four packs of *The Melty Misfits Series 1*, 2012.
6: Complete set of *Jumbo Cheap Toys* (*Double Heather, Graffiti Petey, Alice Island*), resin, 2014.
7: Buff Monster tote bag, 2012.
8: Complete set of *Ice Cream Minis*, produced in 2006, packaged as a set in 2014.
9: Pack of *The Metal Misfits* (9 card set with L'Amour Surpreme).
10: Bronze *Alice Island* with packaging, 1.5" tall, 2014.
11: Packs of *The Melty Misfits Series 2* trading cards/stickers, 2014.
12: *Resin Skull*, 1.5" tall, 2014.
13: Original *Devil Resin Head* and *Jumbo Devil Resin Head*, 1" and 2" tall, 2013.
14: Clear pink (with glitter) *Double Heather* resin figure, 1.5" tall, 2013.
15: Original Sketch cards (front and back) from *The Melty Misfits Series 2*, 2014.
16: Signed cards (front and back) from *The Melty Misfits Series 2*, 2014.
17: Complete box of the *Japanese Melty Misfits* trading cards, 2012.
18: *The Melty Misifts Series 1* sticker album, 2014.
19: Hand-painted *Munny* (top view), 18" tall, 2014.

Toy Machine (detail), 2013.

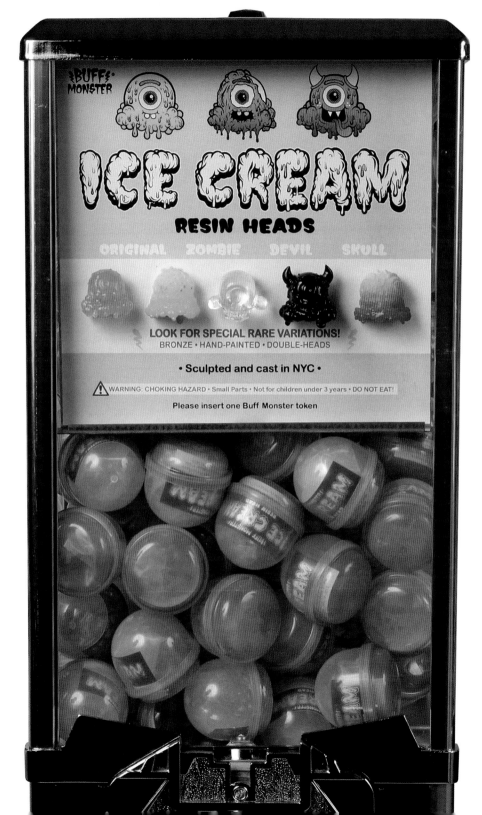